The
Quarantine
Atlas

The Quarantine Atlas

Mapping Global Life Under COVID-19

Laura Bliss
A Bloomberg CityLab Project

BLACK DOG
& LEVENTHAL
PUBLISHERS
NEW YORK

Black Dog & Leventhal Publishers
Hachette Book Group
1290 Avenue of the Americas
New York, NY 10104

www.hachettebookgroup.com
www.blackdogandleventhal.com

First Edition: April 2022

Black Dog & Leventhal Publishers is an imprint of Perseus Books, LLC, a subsidiary of Hachette Book Group,
Inc. The Black Dog & Leventhal Publishers name and logo are trademarks of Hachette Book Group, Inc.

The publisher is not responsible for websites (or their content) that are not owned by the publisher.

The Hachette Speakers Bureau provides a wide range of authors for speaking events.
To find out more, go to www.HachetteSpeakersBureau.com or call (866) 376-6591.

Print book cover and interior design by Katie Benezra

LCCN: 2021940682

ISBNs: 978-0-7624-7812-5 (hardcover); 978-0-7624-7813-2 (ebook)

Printed in Singapore

COS

10 9 8 7 6 5 4 3 2 1

Contents

Foreword

On a warm afternoon in the early months of the pandemic, my daughter dressed up like a spider and danced in the backyard. Her modern dance class had gone virtual, and the recital would be on video. She put on a black leotard with felt spider arms and set up an iPad to film her routine. My wife and I weren't allowed to watch this, so we masked up, leashed up the dog, and headed out on another aimless walk.

The routine of these circuits around the neighborhood had already worn a familiar groove into our heads; only the dog managed to find fresh joy in the experience every day. We'd taken to cutting through strange alleys and wandering farther from the house, longing to see something new. In time we found something: In another backyard, several blocks from ours, there was another little girl dancing around in a different homemade spider costume.

This strange scene turned out to not be that strange, once we figured it out; here, apparently, was another member of my daughter's dance class. They were dancing together, but apart. But it still lingers as one of those moments that seemed to capture the uncanniness of life under lockdown. After months of few opportunities to explore beyond the immediate surroundings, our senses became highly attuned to minute changes in the environment—a fresh bumper sticker on a parked car, new yard signs, the status of area home-improvement projects, an unusually fat squirrel. On Nextdoor, the neighbor-centric social media platform, other homebound residents appeared to be similarly starved for novelty. Amid complaints about leaf blower noise and sketchy visitors, posters announced, "Weird cloud!" and asked, "What's this snake?" We marveled at mundanity.

A trope of the early pandemic was that Generation Xers like myself, by dint of our deep childhood exposure to post-apocalyptic pop culture and facility with TV-saturated self-isolation, were "made for this shit," as *New York*'s Will Leitch wrote in March 2020. We believed that watching *The Day After* and *The Andromeda Strain* as children equipped our cohort with the emotional tools to endure quarantines, field hospitals, and whatever other horrors the pandemic was likely to serve up; their plots taught us that institutions like governments and modern science were likely to fail in their efforts to overcome the threat. Plus, while Boomers and Millennials balked at the deprivations of lockdowns, we were too freighted with family

responsibilities to want to go out. The time to stock up and hunker down had come, as we always knew it would, and we were prepared for what awaited.

In truth, we were not remotely made for this shit, and whatever generational advantage we may have initially possessed evaporated as the months ground on and the long-term miseries of parenting and caregiving under COVID-ized conditions gnawed away at our sanity. The coronavirus crisis also failed to live up to the promise it initially held to my generation of cynics, in that it did not provide much in the way of satisfying entertainment. The pandemic was a kind of anti-spectacle, visible only as things that were not there and distractions we couldn't pursue. Instead of city-swallowing tidal waves and flaming skyscrapers, we got empty buses and closed bars, uncrowded highways, and heaps of takeout containers. Among those who could stay home and stay healthy, at least, the human suffering of COVID-19 in overwhelmed emergency rooms and nursing homes might as well have been happening on another planet.

That's why the images in this book are such valuable documents, in that they allow us to clearly see a phenomenon that was, to many of us, largely invisible: the precise shape and texture of lives broken and reassembled by a catastrophe whose dimensions remained just beyond our field of vision. These hand-drawn depictions of personal worlds collapsed to the neighborhood scale are full of the kind of mundane marvels that landmarked the lockdown lives of others. And they offer something that spiking infection graphs and more traditional depictions of the pandemic's toll don't—a sense that we were all, in various and very different ways, engaged in an epic feat of shared survival.

We're all in this together. The pandemic was just weeks old when this oft-expressed sentiment was exposed as risibly false, so vast was the gulf between how people of different means and persuasions experienced the disease and its disruptions. The waves of outbreaks and lockdowns that rippled on for months splintered the species into often-warring camps marked by geography, ideology, age, and affluence.

Still, it's worth trying to recapture the basic truth of the statement. Though it didn't feel like it, we became witnesses to a once-in-a-lifetime astonishment. A pandemic marching remorselessly across

the planet, the great cities of the world stilled overnight, scientists scrambling to combat a viral invader—this was the stuff of the disaster movies Gen X watched as kids. But in real life, it was a crisis that often played out not as a global blockbuster but as a series of drawing-room dramas in homes and hospital hallways and apartments and backyards, each one isolated from the others, unseeable and unknowable.

It will be the task of the generation that truly was born for this shit—young people who came of age in the pandemic—to tell the truest stories about this crisis, and to prepare for the future ones. Though they were less vulnerable to the virus itself, teens and tweens like my own saw the disease claim great chunks of their childhoods, marking their adult years in ways that the grown-ups can't imagine. For some, the "lost year" of the pandemic is leaving educational gaps and emotional scars; others have adapted and even thrived, as kids raised amid disaster and disruption often do. If we're lucky, COVID quarantine could end up being just one more weird thing in the long string of inexplicable incidents that is childhood. When they become adults, they'll share something amazing with billions of survivors their age, and maybe they'll be able to explain to the rest of us what it all meant.

Until then, we can only gape at the sheer scale of this collective human experience, a natural wonder so vast and diffuse that it defied all our efforts to contain it. We can study the maps that others left behind. And then we can see, at least in glimpses, the web that caught us all.

—David Dudley, 2021

Introduction

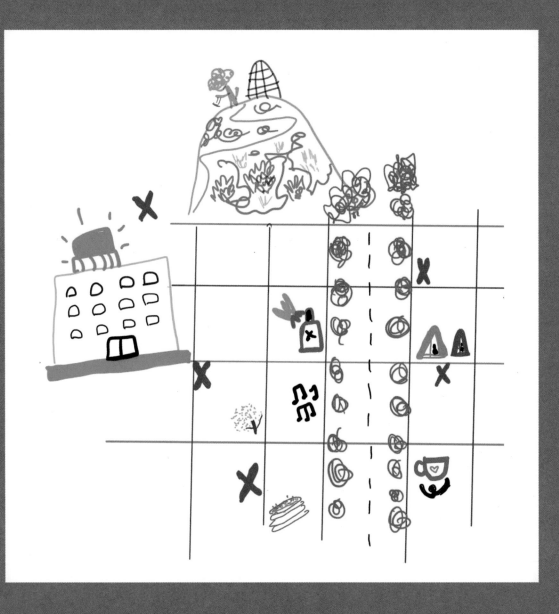

Why Maps Mattered during the Pandemic

Laura Bliss

Toward the end of 2020, I interviewed an archaeologist who—while locked out of her lab due to university health restrictions—was collecting photographs of COVID-19's stamp on public spaces. Latex gloves and polypropylene masks, carelessly discarded in streets, parks, and gutters, featured prominently. She related a horrifying belief: Eventually, these non-decomposable medical accessories would form their own geological layer, a permanent mark of the *annus horribilis* 2020 in our earthly strata.

Whether or not that particular impact is ever revealed, others will be, because archivists, librarians, photographers, and scientists preserved all manner of pandemic-era media. While the coronavirus infected millions, shut down the global economy, and set the table for social and political foment, they saved masks, gloves, and social distancing floor stickers; screenshots from Zoom and online virus-trackers; photographs of food bank lines, restaurant parklets, and mobile morgues; videos of ritualized pot-banging for health workers; anti-vax conspiracy paraphernalia; and so much more.

Such images and ephemera form a kind of "history from below," to borrow a phrase from *The Ghost Map*, Steven Johnson's book about the birth of epidemiology in 1850s London. "Most world-historic events—great military battles, political revolutions—are

◄ **Laura Bliss,** San Francisco, California, United States

self-consciously historic to the participants living through them," he writes. Pandemics are world-changing, too, "but the participants are almost inevitably ordinary folks, following their established routines, not thinking for a second about how their actions will be recorded for posterity." Johnson is pausing to marvel at the fact that modern readers can still discover, in minute detail, the daily habits of long-dead Londoners who lived near what turned out to be an infected pump because they were interviewed by John Snow, the physician who helped crack the origins of cholera by mapping their cases.

Social media and the twenty-four-hour news cycle probably place us in a more self-conscious era than those who lived through the infectious diseases of yore. But it's still true that the sea changes of the COVID era were lived by regular people. If you or a loved one tested positive for the virus, the symptoms, course, and probable origin of the infection—jotted down by a doctor or entered into a health department database—became part of the public health record, available to be studied by science for decades to come. Even if you didn't, your days of sheltering inside, wearing a mask, waiting on taped-up sidewalks, and sacrificing the social time that might have made it all go down easier but was precisely the thing that could kill you: All of that, too, was part of the global socio-political inflection point known as COVID-19, and you were as much a player as anyone. Historians have the archives to prove it.

But what pictures, data, and even fossilized personal protective equipment can't capture is what it *felt* like to live through a horizonless public health disaster. We have harrowing mental health statistics whose implications have yet to be fully reckoned with, such as the tripled rate of depression among US adults, or the one in four young US adults who have contemplated suicide. But what about the specific sadness of a teacher using Zoom in front of an empty classroom, or the fear of a recent graduate navigating the virus on his commute to a grocery store? What about the exhaustion of a parent balancing her work-from-home routine with the demands of two young children, or the pleasure of birdsong suddenly audible against the absence of neighborhood traffic? Such heartfelt ephemera is harder to quantify.

That's what makes the book you're holding so valuable. *The Quarantine Atlas* documents a piece of the emotional turbulence of

the world turning upside down. It presents 65 maps made by people living all over the world during the peaks and valleys of the pandemic, paired with stories they shared. It also includes eight original essays (six of them accompanied with cartography-inspired illustrations by Jennifer Maravillas) that illuminate our changed relationships to our homes, neighborhoods, natural environments, work settings, and other places physical and psychological. All together, the pages before you are a multi-paned window into how the virus transformed our outer and inner landscapes. Born of the twilight hours the world spent at once together and apart, the sum of its parts makes a collective work of art.

How did this project come to be? A few weeks after the World Health Organization declared COVID-19 a pandemic in March 2020, an estimated three billion people around the world were told by their governments to stay at home. As social, economic, and political orders turned inside out, my colleague and CityLab's audience engagement editor Jessica Lee Martin and I had the idea to ask readers to document how the pandemic was reshaping their homes, communities, and everyday spaces in real-time. We published a call-out to readers asking them to create homemade maps and reflect on their new lockdown lives. In MapLab, an email newsletter I write about how cartography intersects with the news, I shared an example: a square-mile-ish grid of my neighborhood in San Francisco, shown with the nearby hospital emanating anxious flash marks from a rooftop siren added for emphasis.

The response overwhelmed us. With pens, paper, digital tools, tiles, clay, and whatever else was around, nearly five hundred people on six continents sent in breathtaking maps and stories. Worry and fear showed up often in these images, but so did inspiring quantities of resilience, hope, and creative spirit. Readers mapped the tight quarters of apartments in Bogor, Buenos Aires, and Istanbul. They mapped the one-kilometer neighborhood areas where they were allowed to range in southern Europe. They mapped the evaporation

of work–life boundaries in homes across Canada, Pakistan, and South Africa, as millions found themselves teleworking, parenting, and grasping for sanity from kitchens and couches. Others mapped the challenges and traumas faced by nurses, bus drivers, and other essential workers thrown directly into the path of a fatal disease.

The uncertainty, the tragedy, the stomach-churning inversion of domestic life: There was no precedent for this stuff, no Google Maps or Yelp to tell anyone how to navigate it. The pandemic tossed out plans for new jobs, visits, weddings, trips. It dried up prospects for work and romance. It taught us the phrase "flatten the curve" but tricked us when a flat curve still meant hundreds of thousands of people sick. As days, weeks, and months melted into slurry, simple narratives of progress, beginnings, and endings no longer held. "What is time?" went the semi-joking quarantine refrain.

COVID also exposed and exploited existing social inequalities so profoundly that the idea of "returning to normal" quickly became unfathomable. In the US, the size of our houses, the health of our finances, and the color of our skin were key preconditions determining life and death. When George Floyd was choked to death under the knee of a Minneapolis police officer in May 2020, it made the lethality of racism all the more undeniable. In honor of Floyd and Breonna Taylor, the twenty-six-year-old woman—an essential worker—who was killed two months earlier by police in her Louisville apartment, millions poured into the streets around the world to protest anti-Black killings and systemic racism, despite health concerns.

Amid shock and upheaval, our pandemic mapping project struck a chord. By pinning down their upended lives to paper, readers could take stock of new, unthinkable circumstances and make them real and knowable to themselves and to others. They could plot observations of an unstable present and grasp relationships as they existed in the moment. Their maps capture specific feelings and ideas playing out in the tumultuous now, rather than concerning themselves too much with what might come next.

The maps also surface how many of COVID's changes relate to location, distance, and geography. In some ways perspectives turned local; in other ways they widened to see the permeability of borders and bodies in the face of pathogens and aerosols. The boundaries between work, family, and leisure bled together inside the home, yet

we also became hyper-aware when we left and re-entered, sanitizing, masking, and psychologically preparing for those transitions. We saw that where we live has much to do with how much risk we face, judging by the disproportionate infection rates in communities of color. Maps have a unique ability to construct meaning about place, and these maps show how individuals from diverse walks of life negotiated the world around them in new ways and with new eyes.

Yet maps can't go all the places words can. This book also includes eight essays by writers who explore how COVID-19 transformed the places they know and their relationships to them. As you read in the foreword by CityLab editor David Dudley, few were prepared for what went down in 2020, not even a generation raised to expect institutional failure and apocalyptic sights. After this, you'll hear from the artist, writer, and professor Taien Ng-Chan about how protest and a voyage around her room helped her reclaim a sense of belonging amid an alarming rise in anti-Asian hate.

The journalist Angely Mercado meditates on lives lost to COVID in her community in Queens, New York, and how mourning was cut off when a normal gathering space went off limits. Writing from Los Angeles, Geoff Manaugh, co-author of *Until Proven Safe: The History and Future of Quarantine*, takes us on a tour of the rearranged streets, sidewalks, and floor plans of COVID-era public spaces and why he sees room for optimism where others might see dystopia. Also from LA, the urban planner and anthropologist Dr. Destiny Thomas tells us why some of the same changes alienated her from industry colleagues and caused her to rethink her concept of inclusive city planning.

You'll also hear from Jenny Odell, the artist and author of *How to Do Nothing*, whose neighborhood walks during lockdown awakened her to natural and social topologies near her home in Oakland, California. Linda Poon, a reporter at CityLab, shows us how a wilderness hike without the friends she'd normally rely on for guidance gave a surprise boost in confidence when she needed it. Sarah Holder, also a reporter at CityLab, retraces a few of the internet rabbit holes she fell down in search of answers that didn't really exist. And my collaborator Jessica Lee Martin shares a wrenching glimpse of what it was like to navigate the pandemic as a working mom of a toddler while in her third trimester of pregnancy.

These essays and most of the maps come from people who were largely insulated from the worst effects of a pandemic, who were able to stay home and work from a computer. That's why you'll also find a reported essay by me that aims to lift up the stories of frontline workers who submitted maps (and one who didn't), since they encountered COVID's spatial upheavals in dramatically different ways from those who stayed home. I regret not having more of their voices and maps in this book. But the ones here stand out for revealing the unique experiences of medical workers, teachers, food service workers, and others in essential occupations, as well as what they have in common.

As I write this in March 2021, almost a year has passed since CityLab invited readers to send in their maps. The pandemic is ongoing, and many of its changes have become gratingly routine. Vaccines are being distributed at an increasingly steady pace, and many of us are starting to imagine life on the other side, even as a mutating virus augurs a long road ahead. That heightened moment when the world stood still, together yet apart, is long past. So is the time for making maps that show the strangeness and stressors of our individual lives.

Still, these maps hold an important place in the record of a phenomenal year. Cartography is often described as a science, and maps are often understood as factual reproductions of the world as it exists. But maps are always subjective. They show us the world as it was once navigated and understood by some person or people, and as such serve as tools for navigating and understanding it ourselves. "The world we take for granted—the real world—is made like this, out of the accumulated thought and labor of the past," the geographer Denis Wood wrote in *The Power of Maps*. "It is presented to us on the platter of the map, presented, that is, made present, so that whatever invisible, unattainable, erasable past or future can become our living now here."

During the pandemic, these maps were tools for empathy and human connection. They helped readers transcend the bounds of lockdown in a way that words could not. In the months and years

ahead, we might look back at them and remember how a landscape of crisis and pain also held pockets of possibility and growth. In their dazzling plurality, they also remind us that no single perspective, assumption, or belief should necessarily define how we see the people around us or the places we live, no matter how long we've held it.

This will be key as the world charts a post-pandemic future. Now is the time for a collective cartography, grounded in hope and solidarity, as we rebuild better systems and relationships with one another and our planet. Such efforts are underway, even if the forces of fear often overshadow them. I think of a chant that rose from Black Lives Matter protesters last summer, a chant that is transformative in its pure insistence that a reality must be seen, must be made true: *Whose streets? Our streets.* That is the map to follow.

Domestic Rearrangements

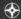

As stay-at-home orders swept the globe, so did
dramatic shifts in indoor living. Some took comfort in
a slower pace. Others chafed against containment.
Worlds shrank to four walls as the virus raged outside.

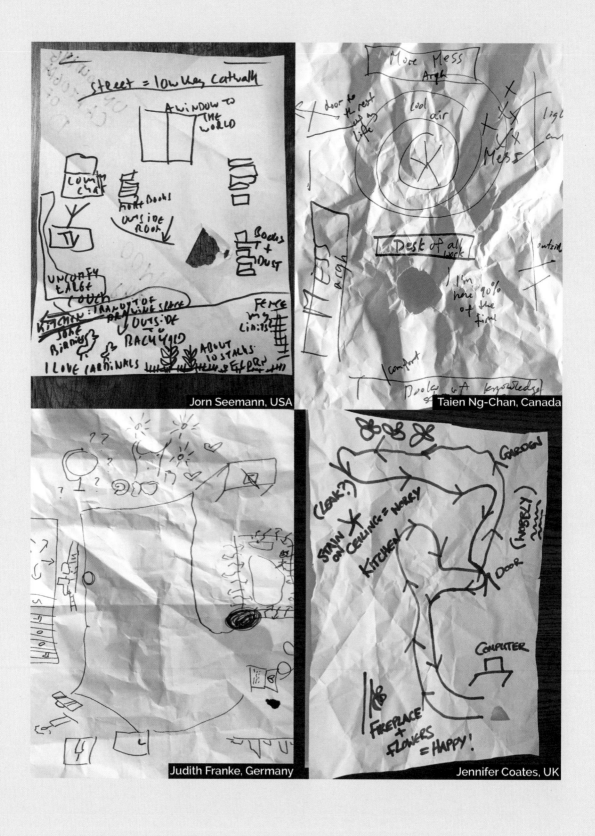

Finding Home in a Locked-Down World

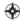

Taien Ng-Chan

In 1790, as punishment for a duel, the French military man Xavier de Maistre was sentenced to forty-two days of house arrest. To amuse himself, he wrote *Voyage Around My Room*, a wildly digressive travelogue parody that catalogs the dimensions of his living space, simple pleasures such as lying in bed, and philosophical flights triggered by the paintings on his walls. The book has become a classic of armchair travel, a concept more recently celebrated by the author Bernd Stiegler, whose 2013 book *Traveling in Place* explores the history of travel as a state of mind, rather than as movement through space.

In 2020, the world went in and out of various states of lock-down, giving me and millions of others the chance to tour our own rooms for what seemed like days upon days on repeat. The movie *Groundhog Day* was referenced often in memes. Public space now felt dangerous. Mixed into the overall fear of contagion was an anxiety about the attendant rise in anti-Asian racism that was circulating in the news and on social media. I stopped going out almost completely. My partner did the grocery shopping once a week, and everything moved online. By April, as time warped into a blur of eat-work-sleep, I began to lose sense of any purpose or pleasure. Quarantine days

◄ **Taien Ng-Chan**, Hamilton, Ontario, Canada (for the Art and Cartography Commission)

took the color out of everything, like a desaturation filter had been turned on in my mind.

This was not the stuff of philosophical or creative inspiration. But as a writer and media arts professor, I have been thinking about public space for years. My research concerns processes of experimental mapping, or as I like to call it, "the art of taking notice" with camera or sound recorder in hand, usually while walking through city streets or taking public transit. I'm interested in ways of seeing and imagining the world differently, and of mapping invisible things like stories, emotions, and perceptions of power, especially as ways to study and challenge the status quo.

Home is a major theme of my inquiries into place. As a second-generation Asian-Canadian in the predominantly white environments of the arts and academia, I came of age studying my surroundings closely in order to figure out how to fit in, how to belong, and even now, I am not completely sure I know how. This idea of home as a place of "belonging" must continually be made and remade, particularly for people of color and anyone on the margins who continually faces hostile environments, microaggressions, racist comments, and other things that make cracks in the façade of home. These "fissures of displacement," as I call them, say that you do not belong.

When the pandemic first began, I started keeping track of the incidents of anti-Asian racism that I would stumble on through social media networks. I read stories about the "China virus," about a grocery store shopper with "Thanks China!" written on her mask, random attacks at bus stops, and Buddhist statues being vandalized. I didn't usually search out news of these incidents, too aware of how overwhelming they might be. But now, at the same time that my indoor living space was becoming almost deadeningly familiar, these reports made public space even more dangerous, and fractured my broader sense of belonging.

When the murder of George Floyd sparked the largest civil rights movement in North America since the 1960s, anger and grief blasted my mind out of its fear and torpor. I began going out again, masked up and in solidarity, to downtown streets where I had not been since the pandemic started, and which took on a new identity as spaces for radical action. Across the world, even mainly white towns and cities saw massive Black Lives Matter protests. In her essay "Choosing the

Margin as a Space of Radical Openness," bell hooks writes about how the experience of being marginalized can be, collectively, a position of strength and energy. I felt that energy on the streets, and it renewed my commitment to the need to find and create spaces, whether digital or physical, where belonging and solidarity could be fostered.

That July, as part of my role as chair of the International Cartographic Association's Commission for Art and Cartography, I was developing a workshop with a group of colleagues for an international conference that had, like most things, moved online. The workshop focused on walking and emotional mapping, and we'd chosen the very 2020 theme of "impending doom"—a tongue-in-cheek reflection of our own felt responses to the pandemic, climate crisis, and structural racism. The challenge was to see if we could map ourselves out of those feelings of dread. If protest and solidarity, sparked by the BLM protests, were key to my personal renewal, could we raise a similar energy to mitigate the overwhelming fear and anxiety that seemed to permeate the globe? Could we cast new light on our too-familiar spaces of lockdown by activating a new sense of connection to a larger picture?

Borrowing from de Maistre's voyage around his room, we carried out a virtual workshop that took thirty walkers from around the world on a tour of their own lockdown spaces. They brought no luggage but two sheets of paper, a writing implement, and instructions to look at everything with the rambling curiosity of a traveler. The first task, as a sort of barometer of feeling, was for everyone to write down their fears and anxieties, which included everything from dictators, militarization, and climate change to "loss of emotional connection" and "overwhelming online work." On the back of that paper, we asked for their sources of comfort: protest, gardening, nature, reading, art, and alcohol. They then tore a small hole in a fresh sheet of paper to represent their locations in space, walked slowly around their rooms to draw their routes and the objects that shaped their surrounding emotional landscapes. "Where are the anxieties located?" we asked. "Where do you find comfort? Reframe your view. Share with us the ground under your feet, the sky outside your window."

The rough, hand-drawn maps that resulted hint at the rich emotions that fill our own interior spaces. In these maps, I can glimpse the lives of others through the squiggly black lines and rough edges

that indicate where their bodies were located, where the windows and quiet spaces are for each. One map details a ceiling stain that speaks to worry, while another map confesses a love of the cardinals who hang out by the cornstalks in the backyard. The last task was for each person to fold, scrunch, rip, and crunch their maps—a transformation of their intangible emotions into 3D paper sculptures, an act of catharsis. Some of them ended up a sharp jumble of edges like mine, others meticulously folded like irregular fans or energetically crushed into tight, crinkled-up balls. The maps were then smoothed out again and displayed by their makers onscreen, the shared act connecting us all in the virtual space of Zoom.

In March 2021, just after the pandemic's one-year anniversary, a white man in Atlanta killed eight people, six of whom were women of Asian descent, in yet another mass-shooting rampage that has become so common in no other country but the USA. Canada doesn't have the same levels of gun violence or COVID, but statistically there are more incidents per capita of anti-Asian hate being reported. #StopAsianHate is trending now, but also #StopWhiteSupremacy, because it is systemic racism that produces the marginalization, the narratives of hatred and violence, the view that this is not our home. The shooting is a culmination not just of pandemic scapegoating, but centuries of simultaneous fearmongering, hypersexualization of Asian women, and racist exclusion. But anger can have purpose. It is only through knowing that others are out there, angry and grieving and shouting and aching, that I can refuse to give in to the fear, and let anger propel me forward to action. We will reclaim our belonging together.

That journey around my room seems so long ago now. I look at my own map, where I've located my piles of mess as sources of frustration, my books as objects of comfort and knowledge, and my desk as my primary location. None of that has changed. But I also see the cool air from the ceiling fan drifting through the summer-warmed room, and all the things that make my room a memory palace. I could tell you the story behind each object in here: a finger painting from when my teenage son was a young child, which reminds me of how much he grew up this year; a red felt square, which is a symbol from my time as a student protester in Montreal; a set of matryoshka nesting dolls gifted to me by a now-departed friend with

whom I had a complicated relationship. My home is made not only of these things, but the stories they carry. Mapping it has helped me to reframe my space, not as a gray place of anxiety and impending doom but a place of invisible connections that have been forged through the networks of friends and allies who sustain me, and whom I help sustain. Spaces—whether public or private, material or digital—are made of relations, and in the face of hatred, that solidarity is a source of strength.

> **Patty Heyda**, St. Louis, Missouri, United States
My map charts the spaces now collapsed into one: my private personal space—kind of messy but vital; my ad-hoc office work space—cramped but creative, family stuff mixed with work affairs; and the Zoom stage set, a corporate professional, publicly oriented space, which, fittingly, is more fabricated façade than actual space. I drew my map in a blended plan, perspective and close-up view, the way life now compresses how we see things. Drawing these multiple perspectives helps me, well, put things in perspective. I see how much we do to prop up work so seamlessly, but I also see how family perspectives become overlaid. Maybe someday our work spaces will accommodate our personal spaces as seamlessly and strategically as we accommodate them.

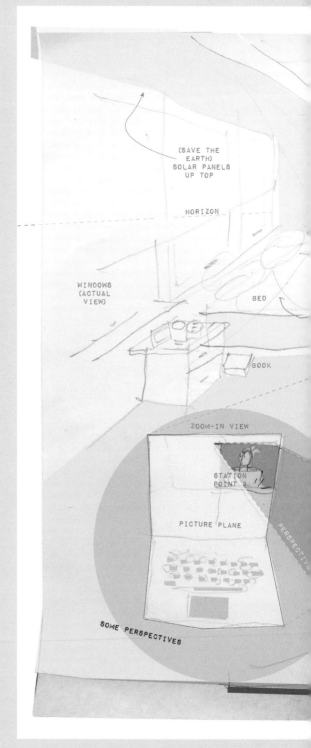

◄ ▲ **Peter S. Conrad**, San Jose, California, United States

We don't go outside at all except to clap with our neighbors, so this home is the whole world now. We talk to our neighbors more, but we see the neighborhood less.

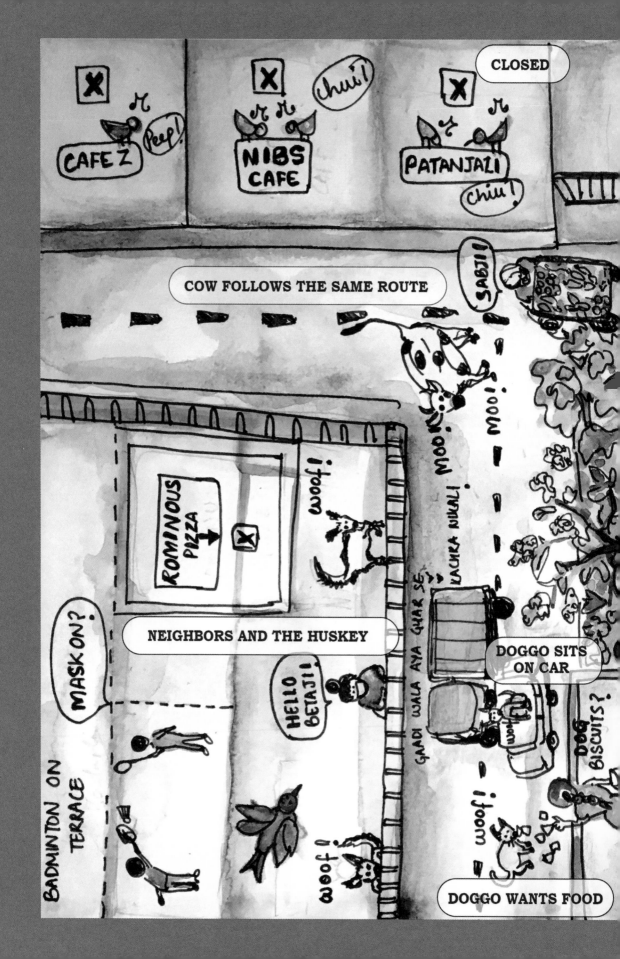

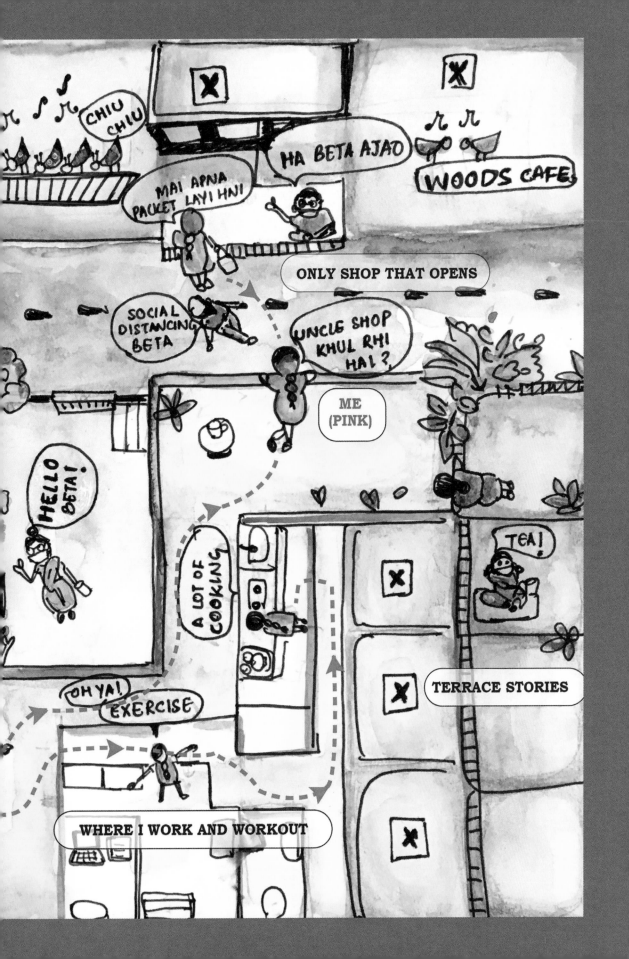

◀◀ Pooja Singh, Jaipur, Rajasthan, India
This is a graphical representation/ map of my activities in my surroundings during this lockdown period. I live as a paying guest alone on the first floor of an apartment in Jaipur and the owners live below. We interact with each other only when I come out in the common open space that connects the terrace, which is during sunrise and sunset. I've been spending a lot of time on my terrace lately as it's the only way I connect to the outer world.

▶ Edda Ívarsdóttir, Kópavogur, Iceland
After spending weeks staying at home working and learning there, it's like our world has shrunk into our house. The city seems so quiet and tranquil; the birds and the cats seem to like it. All the cars are parked in the driveways, which is a nice change. We see people going out more for biking and running than before. It's overall a positive change. I hope we don't go back to the way it was before, at least not all the way.

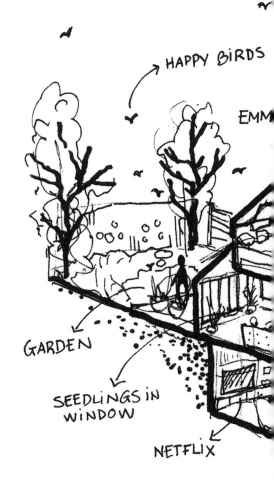

HAPPY BIRDS

EMM

GARDEN

SEEDLINGS IN WINDOW

NETFLIX

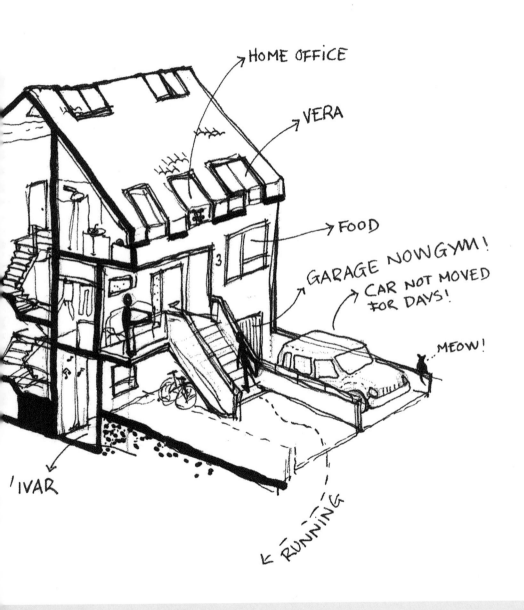

> **Nabilla Nur Anisah**, Depok, West Java, Indonesia

After the COVID-19 outbreak in Indonesia, my company was among the first to instruct us to work from home. It's soon going to be our ninth month at home, and we're getting used to getting everything done by the click of an app. Our dinner table is where we hold our online team meetings, and I shop for everything online. Kudos to all the local entrepreneurs and startups that are quick to adapt to the situation. I've learned to juggle being an employee while also being the center of attention for my toddler. She has interrupted my online meetings, or asked me to play with her here and there, but it has been fulfilling nonetheless. I'll remember that we don't need extravagant trips or to go to every new restaurant for the sake of social existence, because happiness and a sense of fulfillment can be found in our own house in very simple ways, such as baking cookies together or watching our kids grow in front of our eyes.

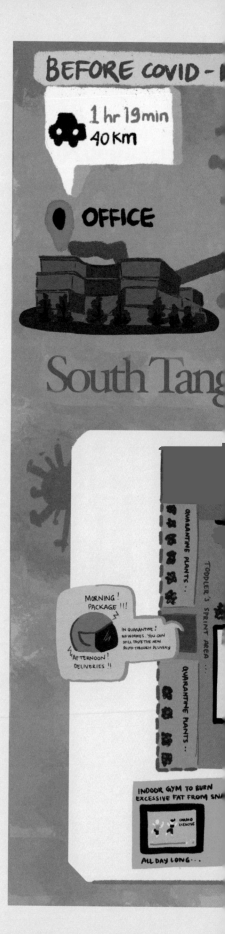

VECINOS QUE APLAUDEN

LUZ POR LA MAÑANA

VENTILA...

JARDIN BOTANICO

SOLARIUM

COMIDA CENA

OFICINA MERIENDA

NETFLIX Y FRÍOS

PERREO

SKYPE APERITIVOS

GIMNASIO

BENDITO LAVAVAJILLAS

PAPEL VIC...

ZUMO

DESAYUNOS INTERMINABLES

LECTURA DORMIR

PANADERIA

LAVAR ROPA INTERIOR

LEGGIN...

EXCURSIONES MÁS POPULARES

MIRADOR A LA COLA DEL LIDL

formas de HABITAR

◄ Blanca Juan García, Madrid, Spain
During lockdown, I've been mostly confined to my home. I have no dog, and I live alone. My walks to the supermarket occur every ten days, more or less. Before the government loosened the rules, my home had become my neighborhood and my world in general.

►► Daniela Pardo, Silver Spring, Maryland, United States
During the pandemic, the home became a micro-city that had to fill multiple needs for individuals and families. This map represents my life at the beginning of the pandemic alongside my partner, meant to showcase the messiness of our lives during the lockdown.

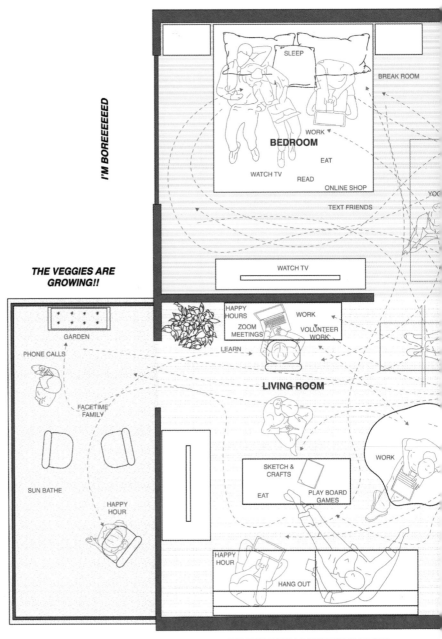

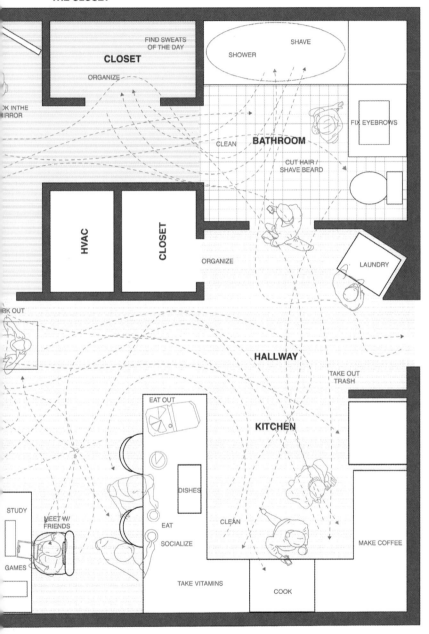

CAN I CUT YOUR HAIR?

WHAT IF WE DYE IT

*BOUGHT STUFF TO RE-ORGANIZE
THE CLOSET*

*WE'RE RUNNING OUT OF TOILET
PAPER*

FIND SWEATS
OF THE DAY

CLOSET

SHAVE

SHOWER

ORGANIZE

FIX EYEBROWS

OK IN THE
MIRROR

CLEAN

BATHROOM

CUT HAIR /
SHAVE BEARD

HVAC

CLOSET

ORGANIZE

LAUNDRY

BK OUT

HALLWAY

TAKE OUT
TRASH

EAT OUT

KITCHEN

STUDY

MEET W/
FRIENDS

DISHES

EAT

CLEAN

SOCIALIZE

MAKE COFFEE

GAMES

TAKE VITAMINS

COOK

*AN YOU GRAB THE MAIL FROM
DOWNSTAIRS*

TAKE OUT?

WHAT ARE WE EATING?

*TODAY I GET MY NEW PAIR OF
SWEAT PANTS!!*

WHERE ARE THE MASKS!?

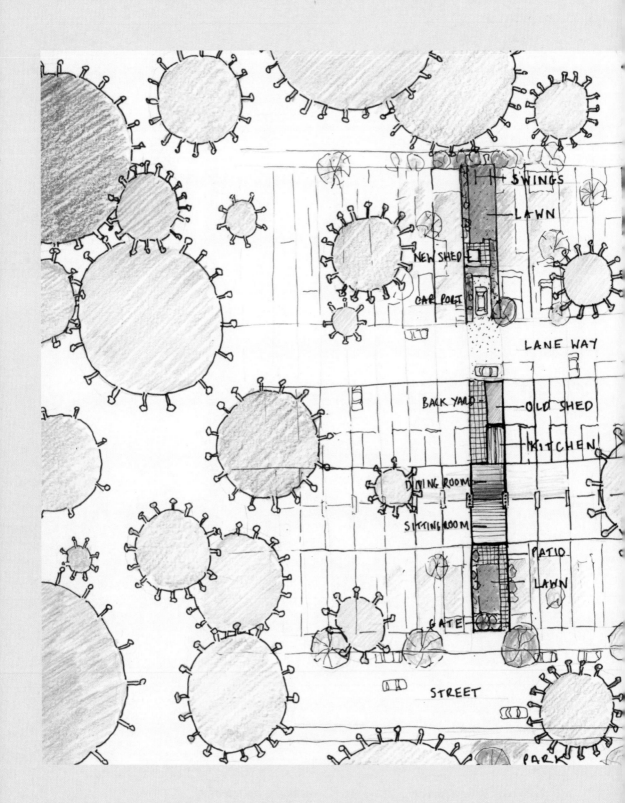

SWINGS
LAWN
NEW SHED
CAR PORT
LANE WAY
BACK YARD
OLD SHED
KITCHEN
DINING ROOM
SITTING ROOM
PATIO
LAWN
GATE
STREET
PARK

◄ **James Hennessey**, Ballyclare, Northern Ireland
More than ever, our little terraced house and garden have become a special sanctuary as we try to keep our family and those around us safe. On the one hand, there is an element of fear as we venture out for necessities, yet on the other, a heightened feeling of compassion for our neighbors and strangers, as we jointly face this new challenge.

> **Sharmaine Montealegre**, Rizal, Philippines

My map shows my daily destination ever since the lockdown started. It's kind of looking like an emergency exit plan, even though since this lockdown began I never step out of our home. My only true emergency exit is to look at the moon and admire how each of its scars makes it even more beautiful.

>> **Sine Taymaz**, Ankara, Turkey

By working, eating, drinking, socializing, and having leisure time in the same space, I watched all four seasons pass by from my window and balcony. From left to right, down to up, I witnessed the changes in nature from all angles within these frames. Outside of the house, I ended up with a pretty regular walking route, which included shopping for necessities and meeting loved ones from time to time, also marked on my map. I will remember this year's missed opportunities and the feeling of helplessness, for not being next to loved ones when they need and want.

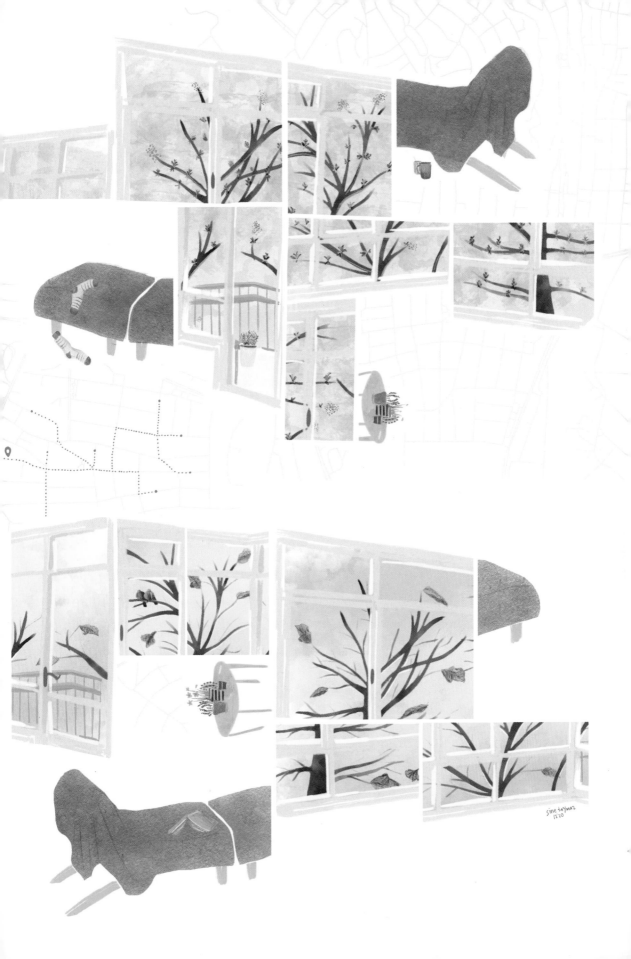

WHERE i TAKE MY SHOES OFF

WHERE i STRETCH AGAINSt THE WALL

WHERE i WATER m PLANt

WHERE i PLAY RECORDS

➤ **Sam Emrich**, Denver, Colorado, United States
This is a drawing of my studio apartment, highlighting activities that were my former "normal" and the ones that are my "new normal" during quarantine, from yoga asanas to solo dance parties to howling out the window every evening at eight p.m. in solidarity. We do it to say, "We can't see each other, but we can hear each other. We're all still here. We're not alone."

□ = NORMAL
□ = NEW NORMAL

WHERE i PRACTICE MY GUITAR

WHERE i GET DRESSED

WHERE i SHOWER + BRUSH MY TEETH

WHERE i WORK OUT, do MY ASANAS, AND HOST SOLO DANCE PARTIES

WHERE i WORK, dRAW, jOURNAL + VIDEO CHAT MY THERAPIST

WHERE i MAKE MY TEA + MY MEALS

WHERE i HOWL OUT tHE WINDOW

WHERE i MEDITATE

WHERE i FALL ASLEEP

WHERE i READ, FACETIME, + EAT BEN & JERRY'S

➤ **Stentor Danielson**, Bellevue, Pennsylvania, United States
Being stuck in my apartment, any adventures or grand journeys I go
on have to be scaled down to match. (And since some of my friends
were confused, the Red and Black God is Netflix.) Everything seems so
much farther away. Even the post office a few blocks away feels like a
dangerous journey now.

➤➤ **Diem-Han (Ti) Dinh**, Seattle, Washington, United States
My map lays out the many places you will find me during quarantine,
all from my couch. From here, I spend time with myself doing work (I'm
a teacher), creating digital and fiber art, connecting with friends and
neighbors over the Marco Polo app, and eating dinner, including the least
couch-friendly meals. As a homebody and introvert, I love the little world
afforded to me during this time.

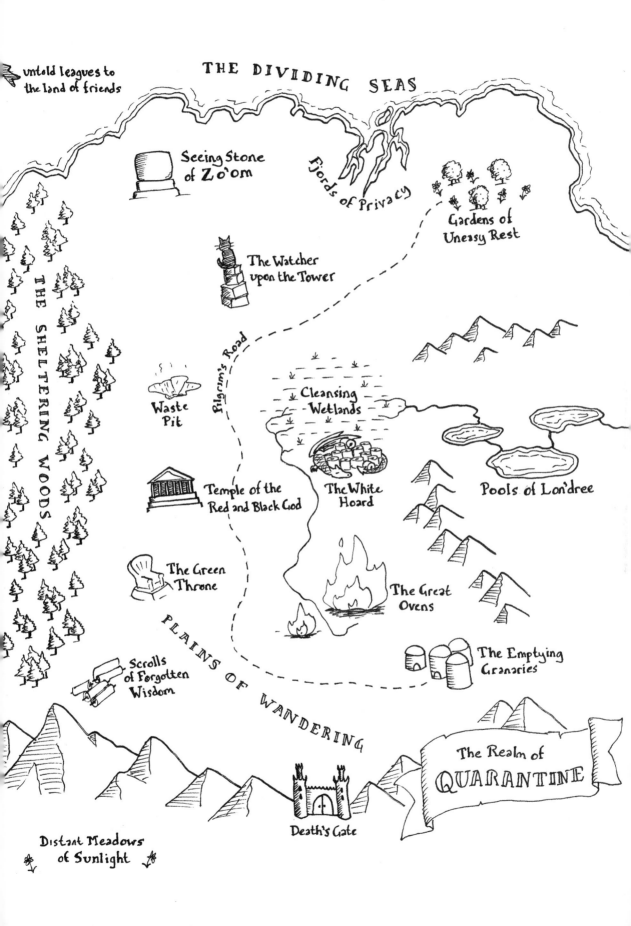

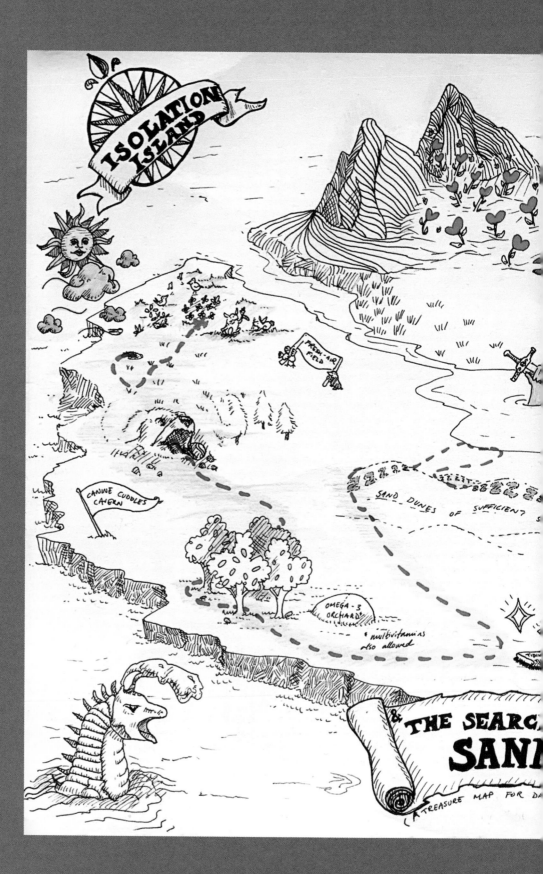

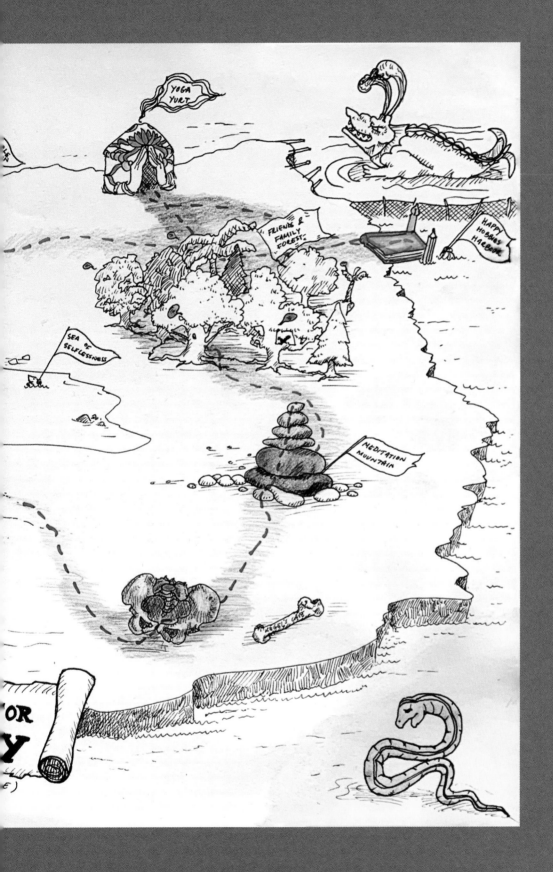

◀◀ **Gro Njølstad Slotsvik**,
Bristol, United Kingdom
This is a reminder to myself of
what to do to stay happy during
isolation. The mountains are
based on the wonderful works
of Christa Rijneveld, and the sea
monsters are from the Carta
Marina (a brilliant sixteenth-
century map of the Nordic
countries). My eleven-month-
old son also tried to help, by
knocking over a cup of cold
coffee onto the corner.

➤ **Francisca Benítez B.**,
Brooklyn, New York, United States
I yearn for my past places
and communities. By finding
moments at home that mirror
the outside world, I try to wash
away the frustrations.

Redefined Communities

With traffic stilled, businesses shuttered, and a
requisite gap between anyone you met on the
sidewalk, city life was stilted by the early days of
the pandemic. But with more time spent close
to home and repurposed streetscapes,
neighborhood bonds tightened.

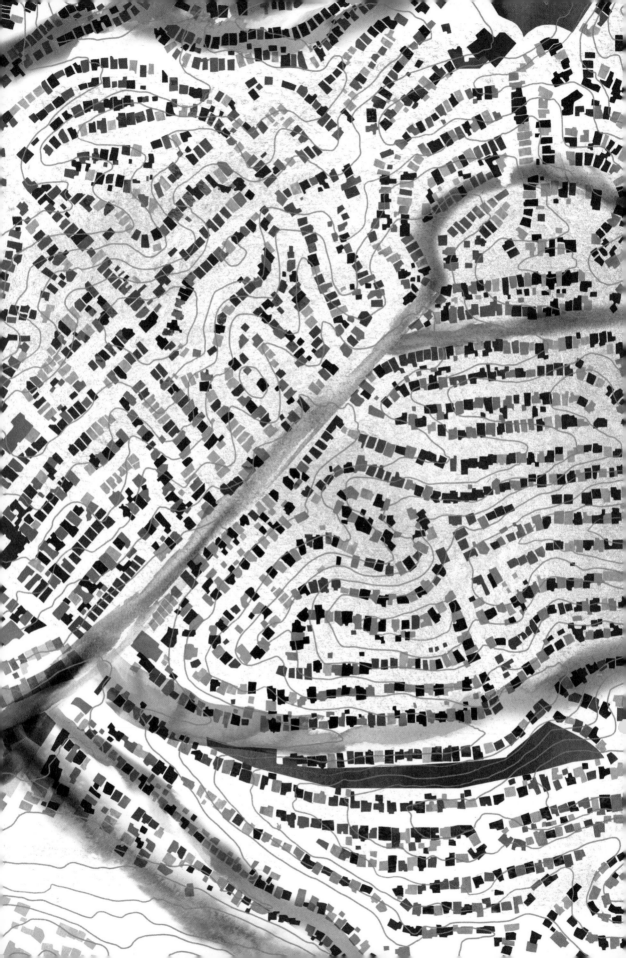

Topographies
of Attention

Jenny Odell

I t took a pandemic for me to realize I was living on a
hill. Before that, I had been dimly aware of the hill in some ways:
It was difficult to parallel park on my street, and whenever I arrived
home from a walk, I was usually a little bit sweaty. For four years I
had looked out the window and seen other people walking up the
hill, sometimes arduously, and during storms, I'd watch trash that fell
out of knocked-over bins roll all the way to the bottom. And yet,
somehow the hill itself never really appeared to me as what it was.

That started to change during the first lockdowns of 2020, when
I began obsessively walking around within about a five-mile radius of
my apartment. Initially, these walks weren't about my neighborhood,
the Lakeshore district of Oakland, California. Instead, they were just
a desperate bid to be moving, to try to populate my mind with images,
smells, and sounds to crowd out the fear and despair of the news
cycle. As the pandemic wore on and novelty became scarce, my walks
became wider variations on a theme: I walked up my hill and down,
up other hills and down, crossing and recrossing the landscape like a
pedestrian 3D scanner.

Eventually, something began to take shape underneath my feet.
Below the pavement and the astronomically expensive single-family
homes with immaculate gardens and hedges, there was the ground,

◄ **Jennifer Maravillas**, Brooklyn, New York, United States

which undulated outward from me wherever I happened to be standing. Looking at a simple street map, you might notice some odd squiggly streets or two streets that appeared to be usually close to each other, but had no streets to connect them. It was only through this repetitive walking that I figured out why: There were steep hillsides, cliffs, ridges, canyons, and creek drainages to contend with. These existed prior to the roads and informed the shape of the roads themselves. In the street map, I could read the echo of a topography I'd barely registered before.

To learn about these shapes, I began visiting Oakland Geology, a blog started in 2007 by the geologist Andrew Alden. Alden, too, had walked around my neighborhood and many others, contextualizing them within geological history and maps. His posts alternate between the maps and his own photos of various streets. It was here that I began not only to see the shape of the neighborhood, but to see that shape as the result of a process: Like many hills and valleys, the ups and downs that I traversed were the product of water draining into the San Francisco Bay. Zooming out from the neighborhood, it turned out also that I lived on the lobe of an ancient alluvial fan (which Alden referred to simply as "The Fan"), sediment carried down out of the hill by various streams.

All of this made me turn my attention back to my own street. I considered it as a hill, as land. For four years I had lived along a stream valley carved by Pleasant Valley Creek without knowing it, partially because the creek is buried under Grand Avenue, a main thoroughfare. Every time I had walked to the coffee shop or the bookstore, I had walked over Pleasant Valley Creek. In fact, embedded in the concrete about a mile away, in a plaza at the head of Lake Merritt, are the names of a handful of underground creeks that converge there. While they are mostly buried, whether beneath concrete or inattention, my body acknowledged their subtle contours when I walked. Upward: Whenever I hunched forward and pushed harder off the soles of my feet, that was because of the water. And downward: When I tilted back and stepped carefully, locking my knees, that was because of the water, too.

The more I walked and adjusted to this lesson in geology, the more I began to examine other fundamental topographies that informed the way I moved through these hills. The vistas of downtown Oakland

and the San Francisco Bay could not be separated from a history of racism and redlining that had left the higher-up neighborhoods overwhelmingly white, nor from the commodification of these views—part of a sedimentation of wealth in the hills that continued into the present. More basically, any sense of ease and curiosity I felt on my walks, particularly in those whiter, wealthier neighborhoods, was a surface expression of my proximity to whiteness and able-bodiedness, as someone who is half white and half Asian and walks without physical difficulty. In other words, I walked not just through a topography of rock and pavement, but of power and privilege, where one of the biggest privileges is simply that of not noticing that the playing field has never been level.

Beneath all of this, my ignorance of the landscape stemmed from my existence as a settler on Ohlone land. Some of the slopes I walked along were formed by Indian Gulch Creek—now either buried or hidden in private backyards, suggested on a map only by the name and curving shape of Indian Road. On his blog, Alden notes that the creek was once the center of a thriving Ohlone encampment, "tucked under bountiful oak trees in a valley with a permanent stream." Although the stream has no way to announce itself, not everyone has forgotten. In 2018, Ohlone tribal spokesperson Corrina Gould and other activists led a "Stolen Land/Hoarded Resources Redistribution Tour" through Trestle Glen, the surrounding neighborhood. Gould is also the co-founder and director of the Sogorea Te' Land Trust, a Bay Area women-led organization focused on returning Indigenous land to Indigenous people. "Our umbilical cords are buried in this land," Gould has said. "Our ancestors' DNA is in this land. And we continue to stand our ground."

As opposed to the inanimate world of real estate and extraction, this is a vision of the land as alive and requiring attention to stay alive—something restless and irreducible underneath the current street map. During the pandemic, in the few places where Oakland's creeks are visible, I would watch the surrounding hillsides in rainstorms, knowing they would never be the same, as sediment washed off them and into the creeks. The land moved in bigger ways, too: In September, a 3.4 earthquake on Hayward fault shook my hill enough to remind me that it was moving north slightly faster than the hills a few miles away. Along with my walks, this not only helped

me see my hill for what it was, unfrozen in time. It also showed that there was nothing given about my hill, nothing to take for granted or lay casual claim to. I was no explorer on an inert land, but closer to an insect crawling through crevices of history. Those crevices are still moving, even right this moment.

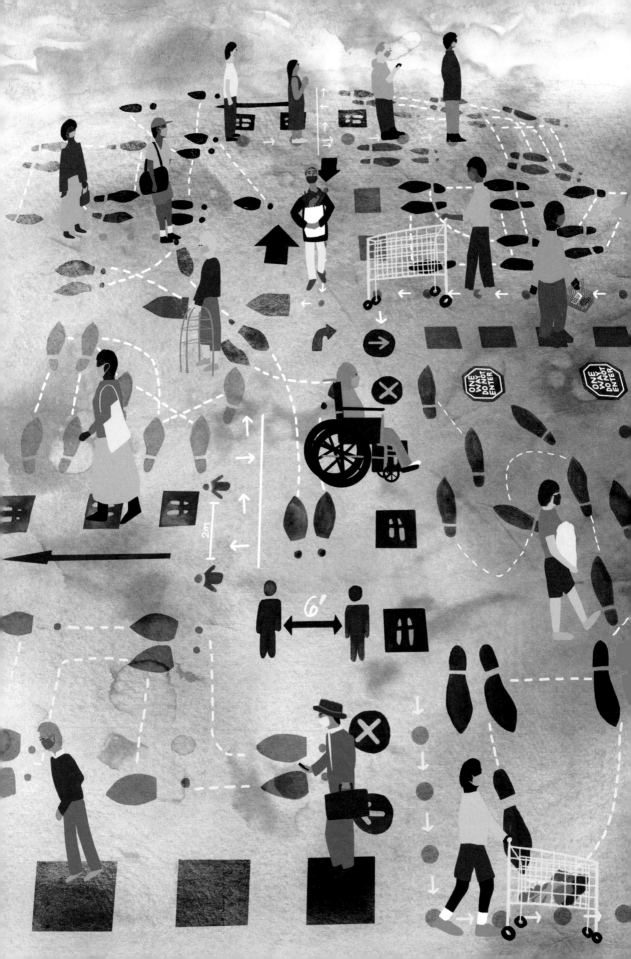

Street Notations

Geoff Manaugh

Originally commissioned by King Louis XIV and named for its eighteenth-century French inventors, the Beauchamp–Feuillet notation system worked as sheet music for feet. It enabled choreographers to codify and record complex movements through a series of printed graphic marks. Depicting the exact steps by which a dancer was meant to cross a floor or stage—or how multiple performers should interact with one another in space—became as simple as giving them the appropriate visual instructions.

The system is no longer much in use, but, during the COVID-19 pandemic, if you lived in a city, as I do in Los Angeles, it was as if such choreographic diagrams had expanded to consume the entire metropolis. Navigating invisible zones of safety and danger meant performing a certain *danse macabre*, maintaining six-foot distances with other people and minimizing the use of hands. Infrastructure reminiscent of an early modern dancer's diagrams popped up to teach us all the right steps.

In the first few weeks of lockdown, this took the form of temporary marks made with duct tape and colored chalk: little lines and X's placed on sidewalks or dashed across the floors of stores in orderly rows. These were meant to indicate where a person should stand while waiting for their turn at the seafood counter or how one body should slip past another by the register without approaching too closely. A

◄ **Jennifer Maravillas,** Brooklyn, New York, United States

seemingly empty space, such as the waiting room of a doctor's office or the parking lot of a hardware store, became dense with choreographic instructions: latent sequences waiting to be realized as soon as someone new arrived to follow them. Floor stickers were placed around and inside elevators to help limit capacity or to remind riders to face away from one another. Most spaces even required a kind of costume change: In almost all storefronts appeared signs requiring masks before entry.

Large indoor facilities, such as grocery stores, began to change their apparent directionality. One-way routes were established overnight, transforming open-plan spaces into rooms more like labyrinths: Follow the path, don't turn around, and eventually you will find your way out again, rewarded with an opportunity to buy canned tomatoes and bulk paper goods. (Items forgotten behind on the shopping route had to be left for a future trip—for my wife and me, only wine seemed worth battling back upstream.) Social distancing—that peculiar art of being in the same place with others while avoiding their microbial influence—could be achieved by treating space itself as a medical concern. In the absence of a drug or vaccine, one's location was the real prescription, public health a question of rigorous choreography.

Just as often, however, these DIY floor notations, with their shoe-scuffed tape marks and blurred chalk lines, either were not entirely clear or were absent from the scene altogether. In those cases, we had to improvise, caught between the logic of Beauchamp–Feuillet notations and the instructions-based graphic work of Sol LeWitt, a twentieth-century American artist whose paintings and drawings are re-created from scratch each time they are displayed, and thus differ ever so slightly from one museum wall to the next. Similarly, public health officials produced consistent rules by which bodies could maintain social distancing. But when applied across spaces as diverse as nail salons, sidewalk cafes, and football stadiums, friction was inevitable. Stay two meters away from strangers—but what if one of you then has to walk in the street? What if the space you're both trying to navigate is less than six feet wide?

Over time, we learned to navigate the unpredictable movements of strangers in knowing silence—stepping a few more inches away from someone or gradually making our mutual, well-spaced way

toward the entrance of a shop. And as the pandemic lingered—as washable chalk marks became more permanent paint—these changes in the city also moved beyond mere graphic notation. Physical hardware began popping up like jewelry pinned to doors and surfaces, altering how we interacted with everyday buildings and objects. It became possible to pull barriers open using not just our hands but with our forearms and even feet, nestling them inside small metal attachments that, mere months earlier, would have seemed revolutionary in terms of urban design.

Amidst these spatial and material shifts was a less immediately visible change: a slower time signature creeping into the streets and intersections around us. On our increasingly lengthy wanders through the neighborhood—the pandemic now dragging on for six months, then for a year, then longer—my wife and I found that almost every pedestrian crosswalk had been reprogrammed. Touchless, automatic, no longer requiring that either of us push a button, the lights simply changed every few minutes.

At first glance, these sorts of alterations appeared ominous, even dystopian, as if we had stumbled on ground-level symptoms of a cultural shift toward atomization and lack of human contact, forcing us literally to count the inches between ourselves and others. After all, those marks on the street and one-way supermarket aisles were there to ensure that we did not interact with strangers; that reprogrammed intersection was there to ensure that we did not touch anything, as if the city should now exist beyond our reach, precious, defying intimacy, keeping us all in a state of managed isolation.

Yet there was also another way to read these COVID-era changes: as a glimpse of a city spatially and temporally scaled to the human body. Although such adaptations were explicitly directed at helping to reduce our exposure to disease, they also had the effect of increasing overall accessibility. Studies have long shown that extending crossing times for pedestrians is a reliable way of keeping our streets safe—for the aged, the injured, the differently abled, the digitally distracted, the struggling families with small kids, for everyone. Yet before the pandemic, far too few municipalities had ever taken steps to implement this advice.

A similar story played out in the "slow streets," emergency bike routes, and pop-up parklets that appeared in LA and dozens of cities

around the world. The reappropriation of driving lanes and parking spots for the use of walking, cycling, and play was a shift dreamed about by progressive urban planners and guerrilla street entrepreneurs alike for generations. This didn't mean every driver paid these changes any attention—as often as not, at least in our neighborhood, cars simply sped down each newly vacant road as if it had been cleared specifically for them—but evening strolls in the middle of the street were suddenly a safe, even an encouraged, possibility. Designing for COVID brought a relaxed, more luxurious time signature into our urban spaces, subtly prioritizing the comfort of bodies over the throughput and storage of cars.

These sorts of downshifts in tempo—these reorientations toward the human scale—were silver linings of a largely brutal time. If there was an urban lesson to COVID-19, it was in the realization that our everyday environments had simply been waiting for the right moment—or, more cynically, the right crisis—to implement a more efficient choreography. The after-effects of earlier outbreaks already surround us at every scale, from steam-based apartment radiators to the international passport itself. This pandemic, too, will leave permanent marks. Even those strange new metal attachments bolted onto shop doors suggest the possibility of an emergent, human-scale urbanism, something we would all do well to remember even long after COVID-19 itself has faded away. We need no longer confuse what's already built with what's inevitable.

On a particularly busy night in our eleventh month of lockdown, while I was out for another walk with my wife, one that took us down to our neighborhood's main commercial street and beyond, pandemic-era Los Angeles was in full bloom. Patrons of take-out restaurants and minimarkets stood on the sidewalk behind tape marks that managed to overlap—safely—from one store to the next, like a well-managed board game; families stood patiently waiting for the walk sign to change, touching nothing, the city's inner timers now accounting for its residents; and strangers negotiated space between one another with nothing more than small head nods or shifts in posture. There were some outliers, of course—there always are—but this new and emerging choreography, it seemed, had begun to find its rhythm.

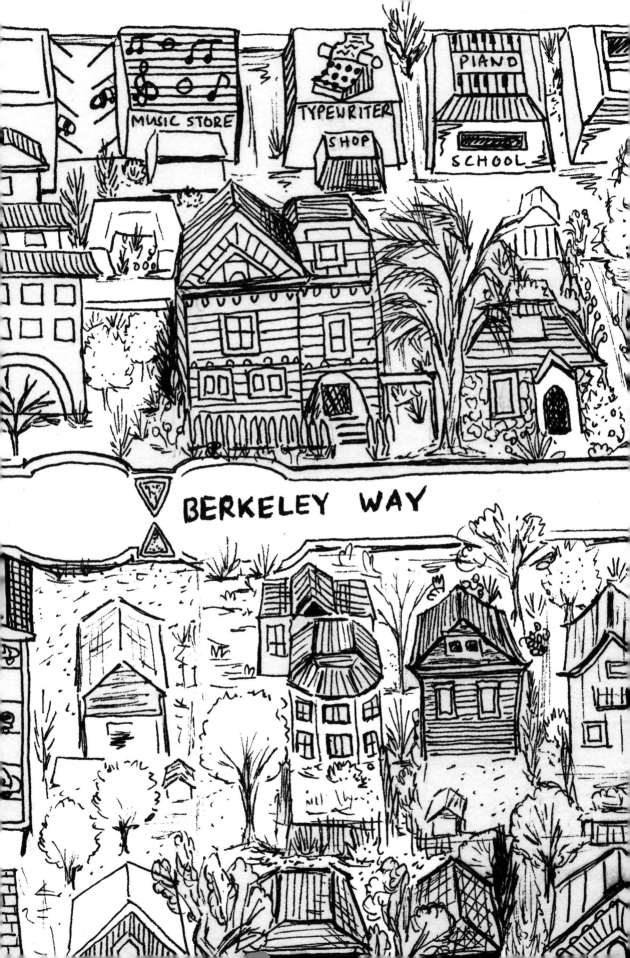

Aditi Shah, Berkeley, California, United States

While drawing this map, I felt increasingly curious about how my neighborhood evolved. I particularly loved drawing the looming redwoods and clashing architecture. Even though this map isn't accurate, looking at it makes me appreciate deeply the privilege of where I live during these strange times.

Reflecting a year later, there has been fundamental change. Many of the businesses are, unfortunately, closed. Public transportation has come to a halt. The bus stop is hardly frequented. The wonderful Greek owners of Cafe Nostos have managed to stay afloat but have struggled with the compounding issues of being elderly in a pandemic and managing a business dependent on socializing. So now when I look at this map, I feel bittersweet and nostalgic. The only moment it is truly reflective was in the moment I drew it, and even then, the neighborhood was changing.

Amit Krishn Gulati, Gurugram, Delhi–National Capital Region, India

My quarantine map extends the sights and sounds of my immediate surroundings: the studio at home, the little garden outside, my nighttime walking paths, as well as the places I've physically and virtually transported myself to during the lockdown. These appear in the form of a montage of objects, creatures, poetic meanderings, aerial topographies, and plans viewed through binocular frames. My map is a metaphor for time and space twisted by the imposition of a new and constrained frame of reference, bringing together far-flung places that now exist together. The north Indian rivers, the Ganges and the Yamuna, also feature, binding the physical, the temporal, and the spiritual with their fluid, shape-shifting forms and transporting us through our new, permanently distorted reality.

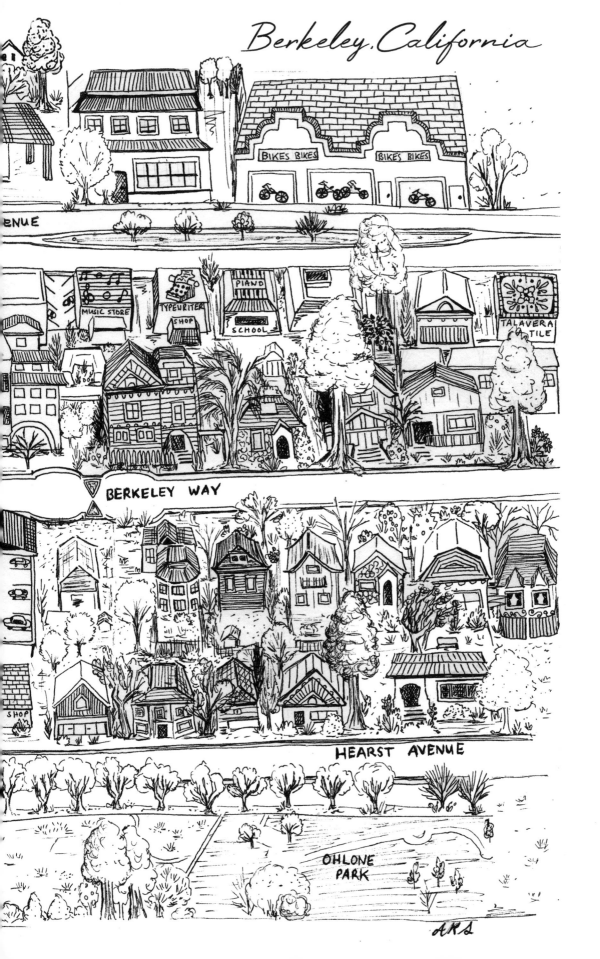

Berkeley, California

ENUE

BIKES BIKES BIKES BIKES

MUSIC STORE TYPEWRITER SHOP PIANO SCHOOL TALAVERA TILE

BERKELEY WAY

SHOP

HEARST AVENUE

OHLONE PARK

ARS

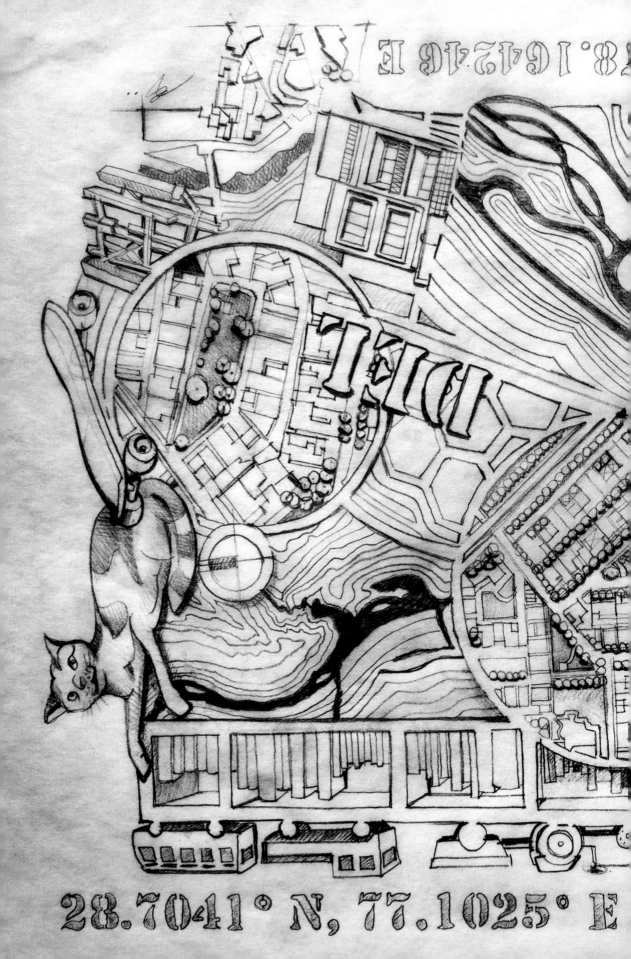

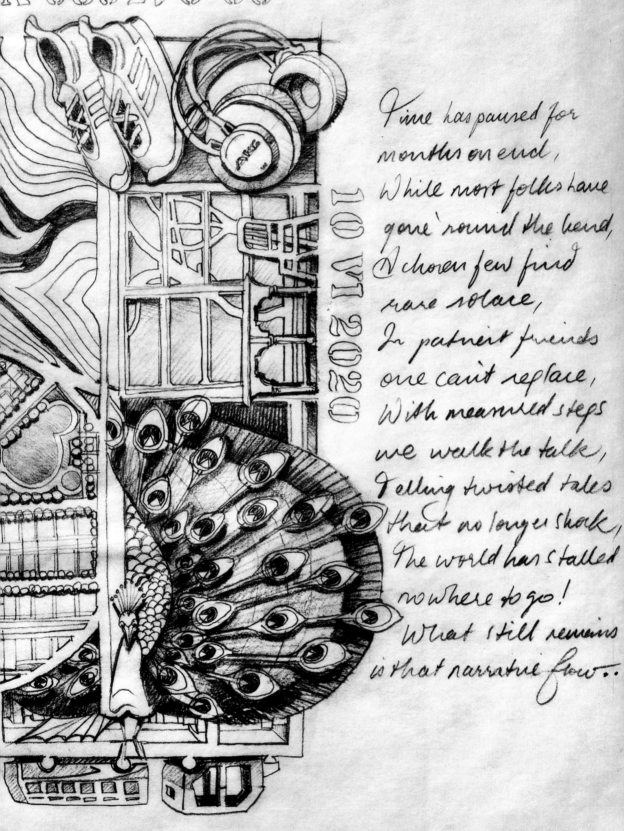

10 VI 2020

Time has paused for
months on end,
While most folks have
gone 'round the bend,
A chosen few find
rare solace,
In patient friends
one can't replace,
With measured steps
we walk the talk,
Telling twisted tales
that no longer shock,
The world has stalled
nowhere to go!
What still remains
is that narrative flow...

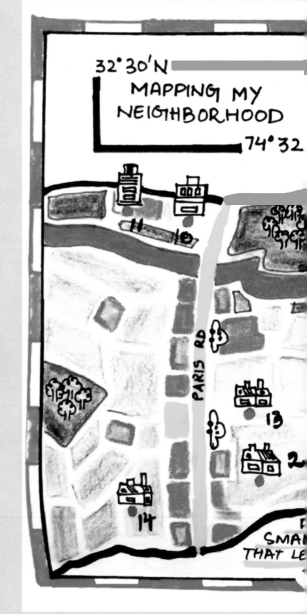

➤ **Amna Azeem**, Sialkot, Pakistan
Being raised in a neighborhood that is very active socially and is located in the heart of downtown with all the necessary facilities available nearby has enabled me to make unforgettable memories, a glimpse of which I have shown in the map. This epidemic has made us realize the little things we used to take for granted. Coronavirus has no doubt changed our lives by making us stay indoors. I feel very nostalgic when I think about the activities that I used to do. For now, my relationship with the neighborhood is limited.

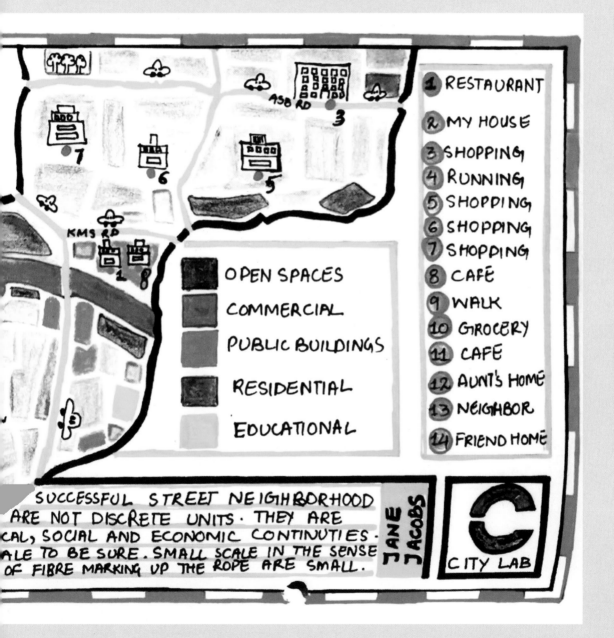

1 RESTAURANT
2 MY HOUSE
3 SHOPPING
4 RUNNING
5 SHOPPING
6 SHOPPING
7 SHOPPING
8 CAFÉ
9 WALK
10 GROCERY
11 CAFÉ
12 AUNT'S HOME
13 NEIGHBOR
14 FRIEND HOME

OPEN SPACES

COMMERCIAL

PUBLIC BUILDINGS

RESIDENTIAL

EDUCATIONAL

SUCCESSFUL STREET NEIGHBORHOOD
ARE NOT DISCRETE UNITS. THEY ARE
CAL, SOCIAL AND ECONOMIC CONTINUTIES.
ALE TO BE SURE. SMALL SCALE IN THE SENSE
OF FIBRE MARKING UP THE ROPE ARE SMALL.

JANE JACOBS

CITY LAB

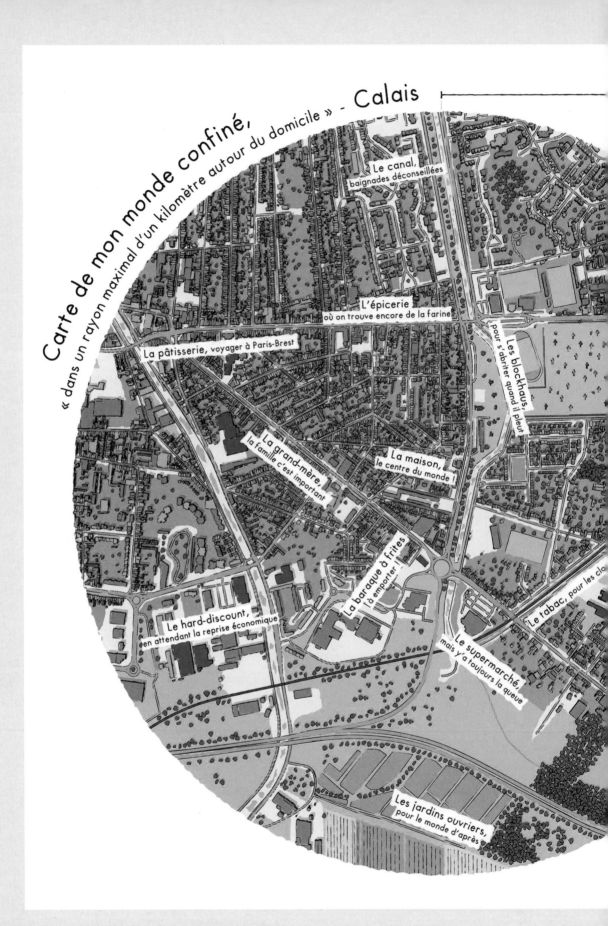

Carte de mon monde confiné, « dans un rayon maximal d'un kilomètre autour du domicile » - Calais

Le canal, baignades déconseillées

L'épicerie où on trouve encore de la farine

Les blockhaus, pour s'abriter quand il pleut

La pâtisserie, voyager à Paris-Brest

La grand-mère, la famille c'est important

La maison, le centre du monde !

La baraque à frites, à emporter !

Le hard-discount, en attendant la reprise économique

Le tabac, pour les clo...

Le supermarché, mais y'a toujours la queue

Les jardins ouvriers, pour le monde d'après

etière,
us tard

L'hôpital,
ça peut servir !

Données : © les contributeurs OpenStreetMap // Arthur Beaubois-Jude, avril 2020

◄ **Arthur Beaubois-Jude**, Calais, France
During the first lockdown in France, if you had no
professional or emergency reasons to go out, you
had to stay at home, or you could take a walk
within a one-kilometer radius. I've done a map
of my authorized living perimeter, and indicated
the places of interest inside this little world. The
center of my world? My home! I'm usually a stay-
at-home person. But now, I just want to get out of
this perimeter.

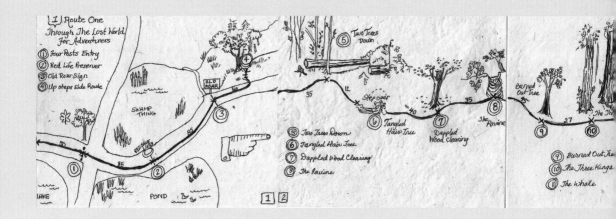

▲ ➤➤ **Axel Forrester**, St. Leonards-on-Sea, East Sussex,
United Kingdom
We discovered a beautiful old canyon near our house that looks like a lost
world. My husband has been doing research on the history of the area
and discovered that it was sold to the local council at cost for the public
to enjoy in 1933 by a man named Herbert Povey. I wanted to make a
fancy map for my grandson to discover it too when this lockdown is over.
We moved here in November, and we've certainly been discovering every
inch of it, walking it every day. We love being close to Alexandra Park and
these lovely hills, but this hidden valley is our favorite. It even has several
waterfalls. We call it the Lost World Trail.

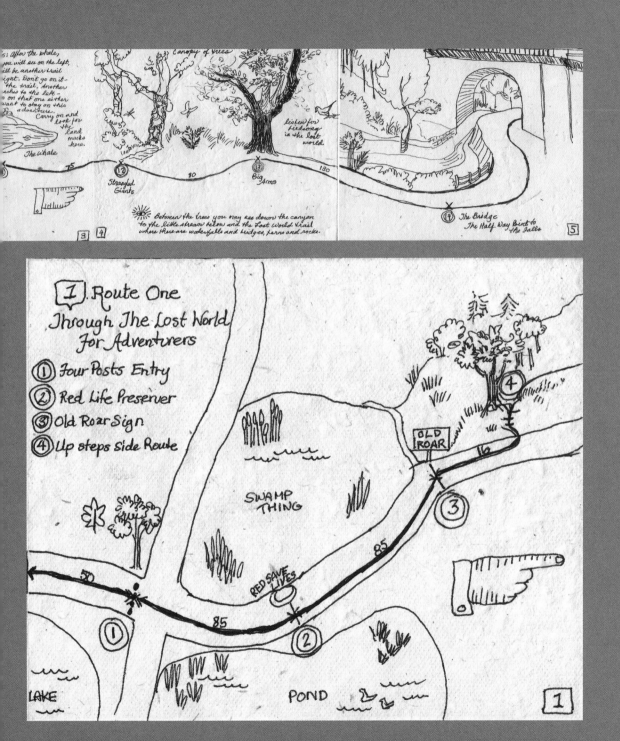

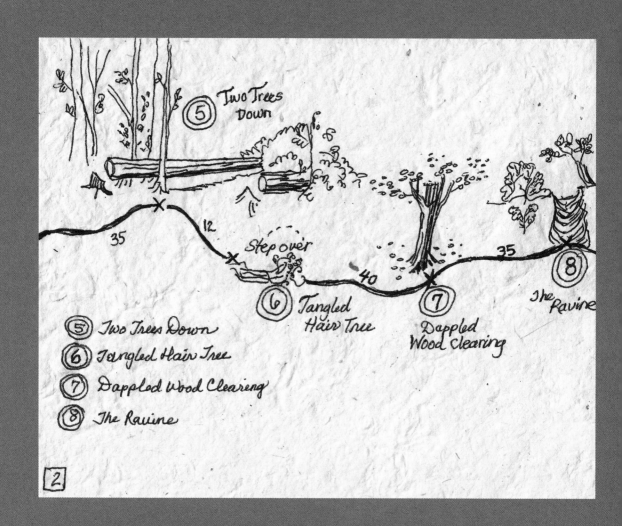

5 Two Trees Down

35 12

Step over

6 Tangled Hair Tree

40

7 Dappled Wood Clearing

35

8 The Ravine

5 Two Trees Down
6 Tangled Hair Tree
7 Dappled Wood Clearing
8 The Ravine

2

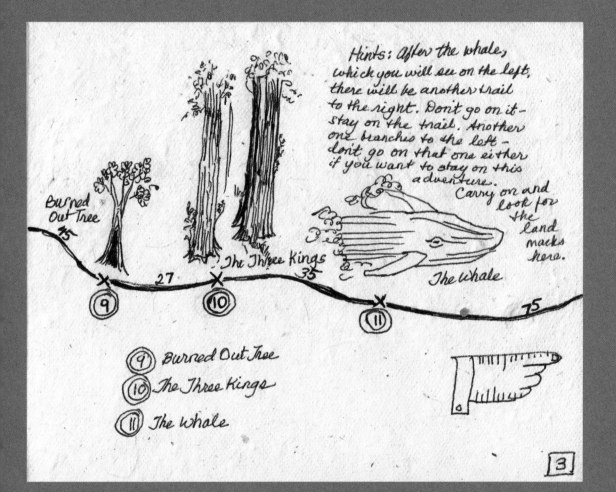

Hints: After the whale, which you will see on the left, there will be another trail to the right. Don't go on it - stay on the trail. Another one branches to the left - don't go on that one either if you want to stay on this adventure.
Carry on and look for the land marks here.

Burned Out Tree
45

The Three Kings
35

The Whale

27

75

⑨ Burned Out Tree
⑩ The Three Kings
⑪ The Whale

3

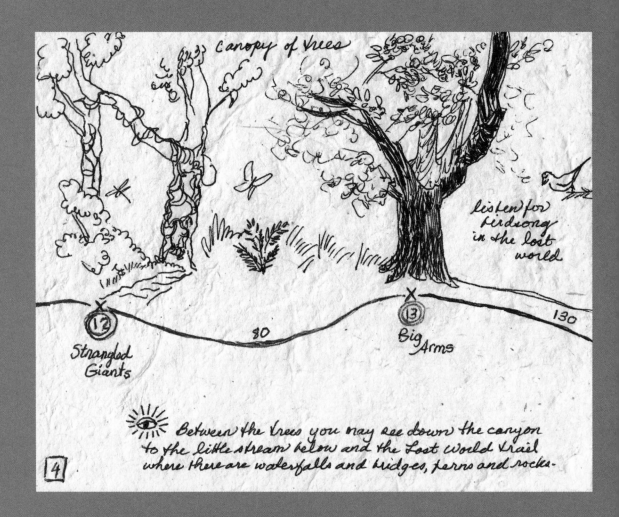

Canopy of trees

listen for
birdsong
in the lost
world

12
Strangled
Giants

80

13
Big
Arms

130

4

Between the trees you may see down the canyon
to the little stream below and the Lost World trail
where there are waterfalls and bridges, ferns and rocks.

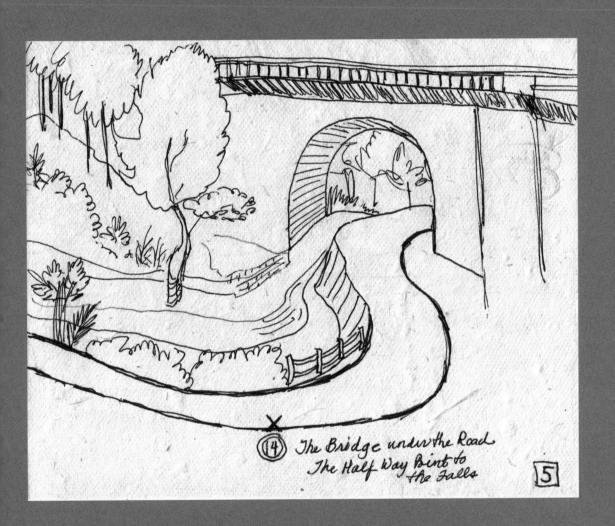

(14) The Bridge under the Road
The Half Way Point to
the Falls

5

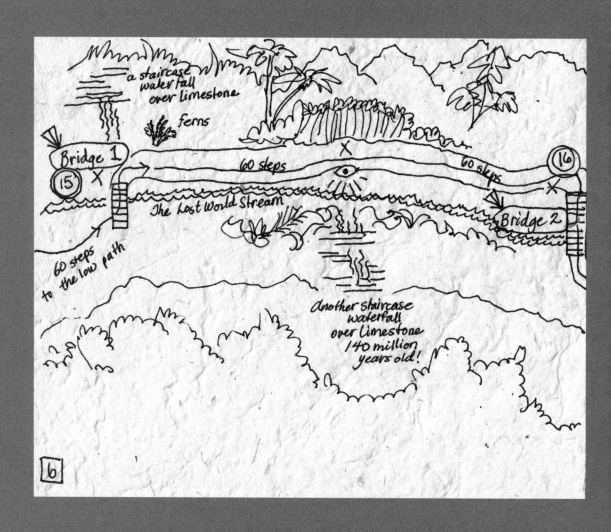

a staircase water fall over limestone

ferns

Bridge 1

15 X

60 steps

The Lost World Stream

60 steps to the low path

60 steps

16

Bridge 2

X

Another staircase waterfall over Limestone 140 million years old!

6

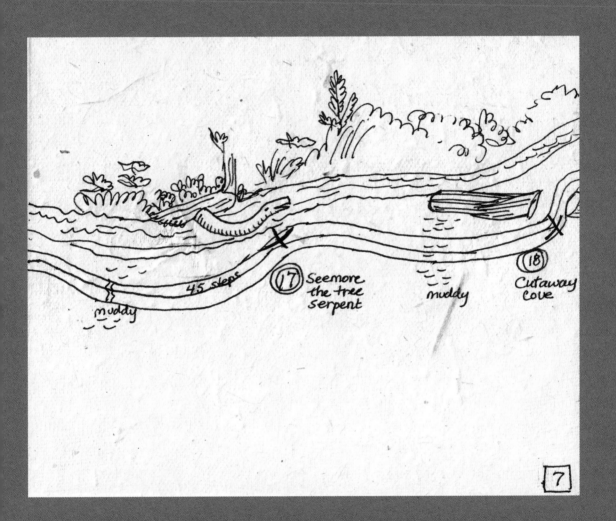

muddy

45 steps

⑰ Seemore
the tree
serpent

muddy

⑱ Cutaway
cove

7

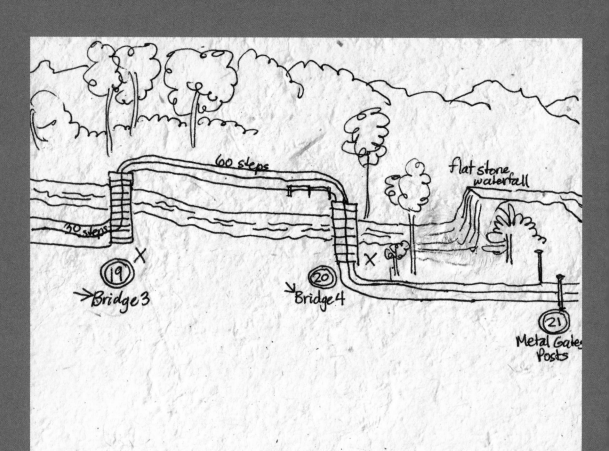

60 steps

flat stone
waterfall

50 steps

X

⑲
→Bridge 3

⑳
↓Bridge 4

X

㉑
Metal Gates
Posts

8

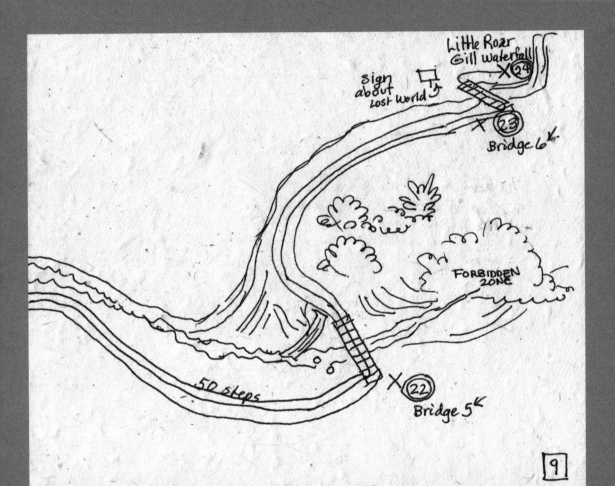

Little Roar
Gill waterfall
X ㉔

sign
about
Lost World

X ㉓
Bridge 6

FORBIDDEN
ZONE

50 steps

X ㉒
Bridge 5

9

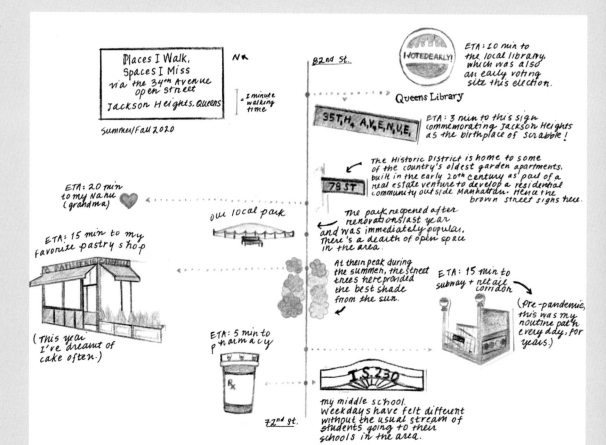

Places I Walk,
Spaces I Miss
via the 34th Avenue
open street
Jackson Heights, Queens

N ←

Summer/Fall 2020

= 1 minute
walking
time

82nd St.

NOTEDEARLY!

ETA: 10 min to
the local library,
which was also
an early voting
site this election.

Queens Library

35TH, AVENUE,

ETA: 3 min to this sign
commemorating Jackson Heights
as the birthplace of Scrabble!

ETA: 20 min
to my Nanu
(grandma) ♥

The Historic District is home to some
of the country's oldest garden apartments,
built in the early 20th century as part of a
real estate venture to develop a residential
community outside Manhattan. Hence the
brown street signs here.

79 ST

our local park

The park reopened after
renovations last year
and was immediately popular.
There's a dearth of open space
in the area.

ETA: 15 min to my
favorite pastry shop

At their peak during
the summer, the street
trees here provided
the best shade
from the sun.

ETA: 15 min to
subway + retail
corridor

(Pre-pandemic,
this was my
routine path
every day, for
years.)

(This year
I've dreamt of
cake often.)

ETA: 5 min to
pharmacy

Rx

I.S. 230

my middle school.
Weekdays have felt different
without the usual stream of
students going to their
schools in the area.

72nd St.

◄ **Rawnak N. Zaman**, Queens, New York, United States
During the pandemic, New York City closed neighborhood streets across the five boroughs to vehicular traffic under its Open Streets initiative, granting pedestrians and cyclists much-needed space to move more freely while social distancing. I often walk along the 34th Avenue Open Street in Queens, which runs between 69th Street and Junction Boulevard. Thirty-fourth Avenue is a convenient thoroughfare. My map depicts my walking route, which takes less than fifteen minutes one way, and how some of my favorite or essential sites (and sights!) in the neighborhood of Jackson Heights connect to the Open Street. With the pandemic and subsequent lockdown, the movement of vehicles, travelers, and passersby alike came to an abrupt standstill. The ripple effects could be felt in the little things: a craving for cake that went unmet, video calls with family who live just down the street, a stillness in place of the usual flurry of activity that signaled the start of a new school year. Walking was therapeutic after months of mostly solitary contemplation, and in the absence of sufficient open space I favored the Open Street and blocks with abundant street trees.

> **Simo Capecchi,**
Naples, Italy
In green are the allowed paths, connecting my home to the nearest supermarkets. In red is the forbidden zone, including all the beauty and activities we normally enjoy in the gulf of Naples. Red dots mark my detours to say hello to a friend from a balcony, to reach a view with the sea, or to climb rooftops nearby. I am lucky enough to be healthy, to have a house and a view. At night, our only skyscraper's windows light up with different messages like LOVE, HOPE, and LIFE. Every evening I wait to see if they change it.

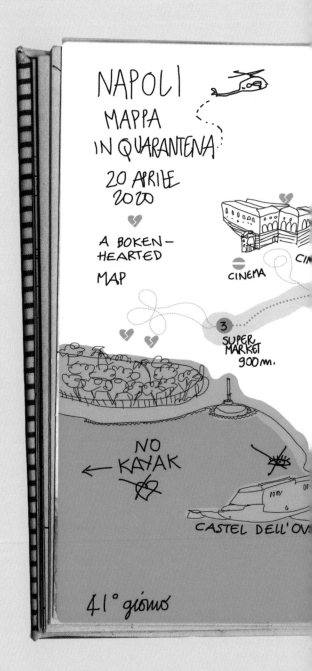

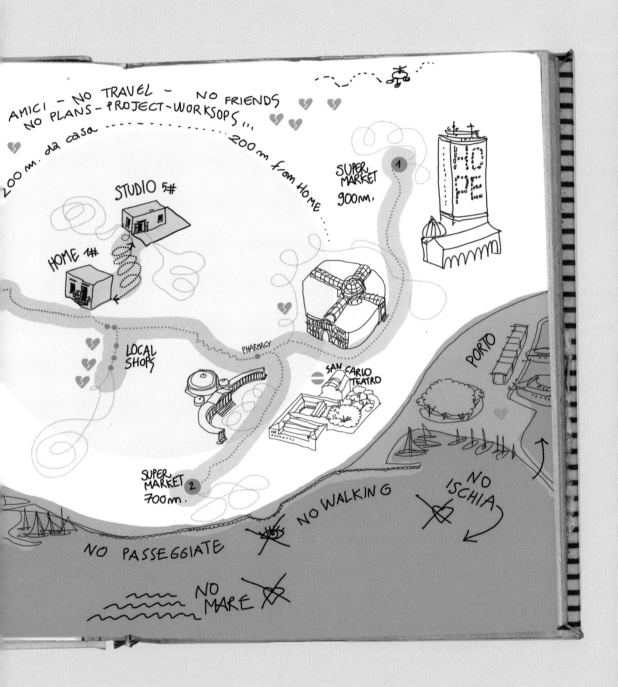

➤ **Lisa Rose Drury**, Guelph, Ontario, Canada
My world has shrunk, which has made me feel a lot more limited, but in some ways I notice things I always ignored. I also see the same people over and over, walking the same paths as me, who I didn't know lived in my neighborhood. That in itself is nice, but I hate feeling like they are scared of me, like if I got any closer I wouldn't just be a neighbor, but a real threat.

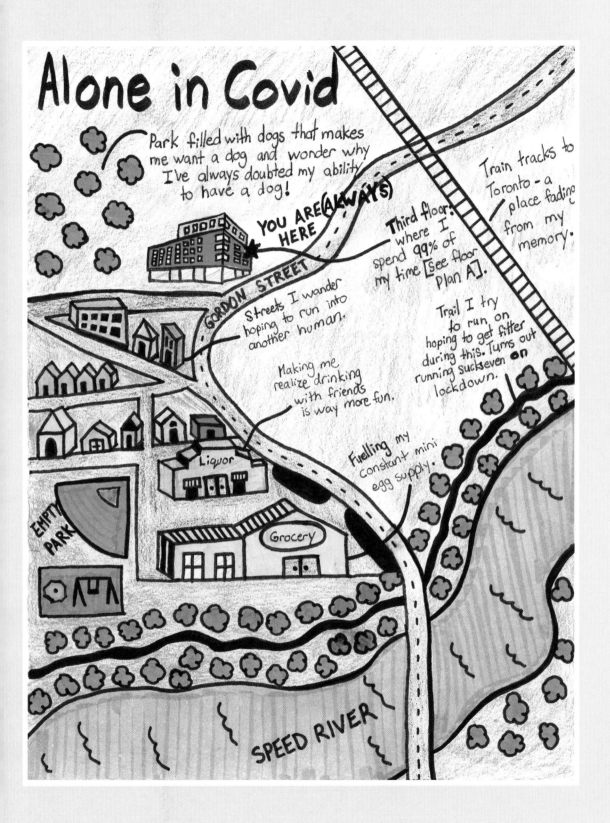

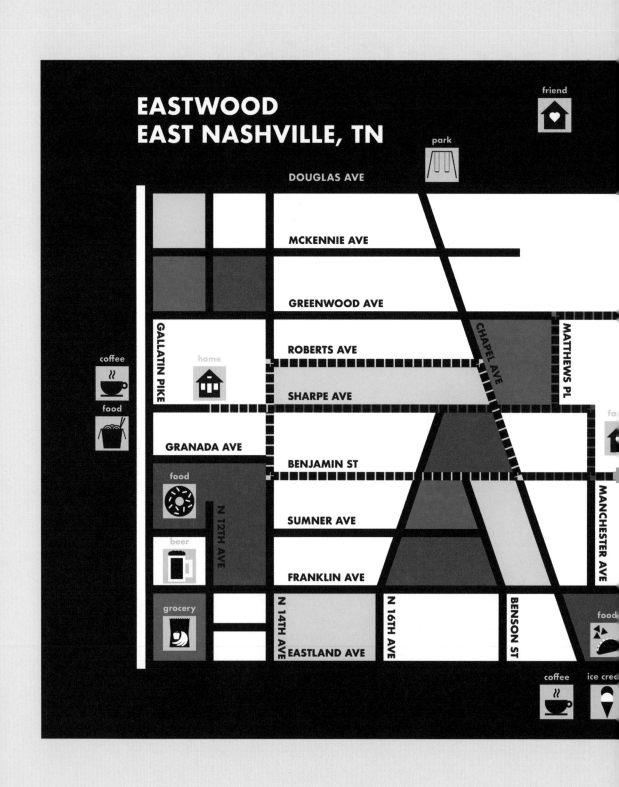

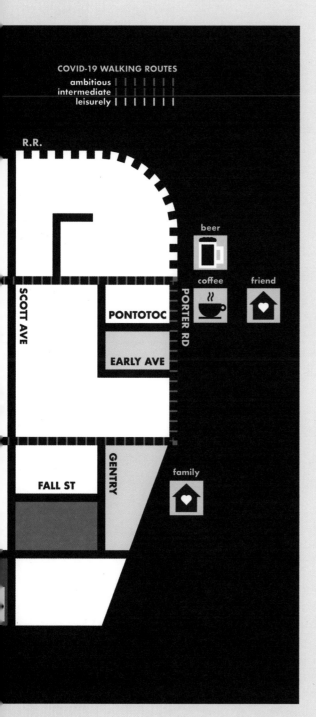

◄ **Eric Hoke**, Nashville, Tennessee, United States
My map is focused around regular walking routes in our neighborhood. It shows the actual boundaries of Eastwood, a neighborhood within East Nashville, but the focus is the landmarks that my family has been frequently visiting during the pandemic. During recent walks, we have developed much better relationships with our neighbors because everyone is outside more.

➤ **Nawaf Al Mushayt**, Lisbon, Portugal

Famous streets, cafes, beaches, and train stations show the changing relationship to public space during the pandemic. Milan's cafes, Times Square, the Champs-Élysées, and even mosques, temples, and churches are free of humans. The global pandemic has made society united in humanity's survival. But it has also disrupted the most essential element of city life: public life.

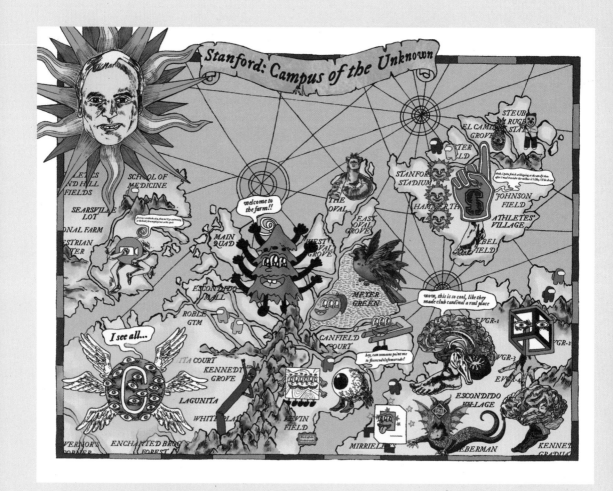

Lydia Wei, North Potomac, Maryland, United States

Instead of experiencing my freshman year of college on a new campus, the pandemic found me at home in Maryland, logging into class via Zoom every day. Though I was able to familiarize myself with some of the rituals, in-jokes, and (digital) spaces of Stanford University, I had no clue what it was like as a real, physical place. It was with this spirit of knowing and not-knowing in mind that I created a fantastical map of Stanford that was a chaotic blend of both what I'd experienced of university so far and what I anticipated the "true" on-campus experience to be like.

For example, I rendered Zoom—so ubiquitous to online learning—as a mythical, sentient being, and included the confusing slang of on-campus locations like "The Dish," "Arillaga," and "Tressider." My map also contains some references to the experiences and fads of quarantine, like the online game Among Us. The cartoonish, many-eyed

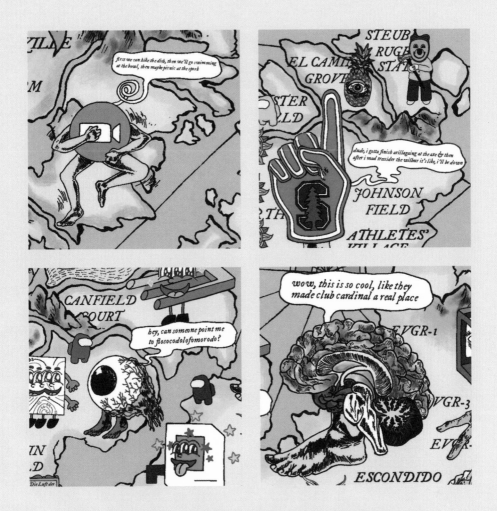

creatures are an homage to Keith Haring, one of my favorite artists, and just an expression of the fantastical, bizarre feeling of starting university online. Just like me, this map is stuck in a real limbo state: It's neither entirely true to the experience of attending Stanford virtually, because it's peppered with my hopes and half-baked conceptions of campus, nor is it entirely true to the experience of being there.

I'm excited to head onto campus sometime soon (hopefully), and I won't always be this clueless about the Stanford campus. But I've enjoyed seeing how my brain fills in the gaps between what little bits and bobs I know to make something very silly and special. It's definitely a strange time right now to be starting university—but in a weird way, I've been able to find and create my "own" Stanford at home, sort of like I would have done on campus. And I suppose that experience is quite dear, no matter how bizarre and unconventional that version of university life is.

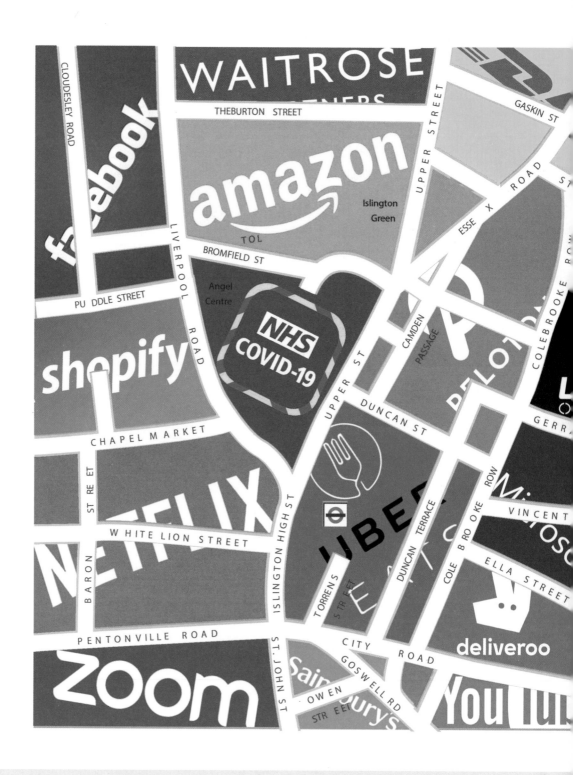

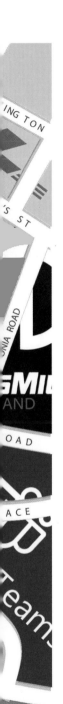

◄ **Alfonso Pezzi**, London, United Kingdom

The map represents the transformation of my neighborhood, where apartments have become multipurpose spaces for gym, cinema, office, and virtual congregation areas. I spend 95 percent of my time in a tiny apartment in the center of London. I don't need to take the Tube to go to my workplace, the cinema, my favorite restaurant, or church. Everything is delivered to me, seamlessly and instantaneously. I spend the remaining 5 percent walking in my neighborhood, where I see strangers living the exact same life I live, all itching to return to some semblance of normalcy.

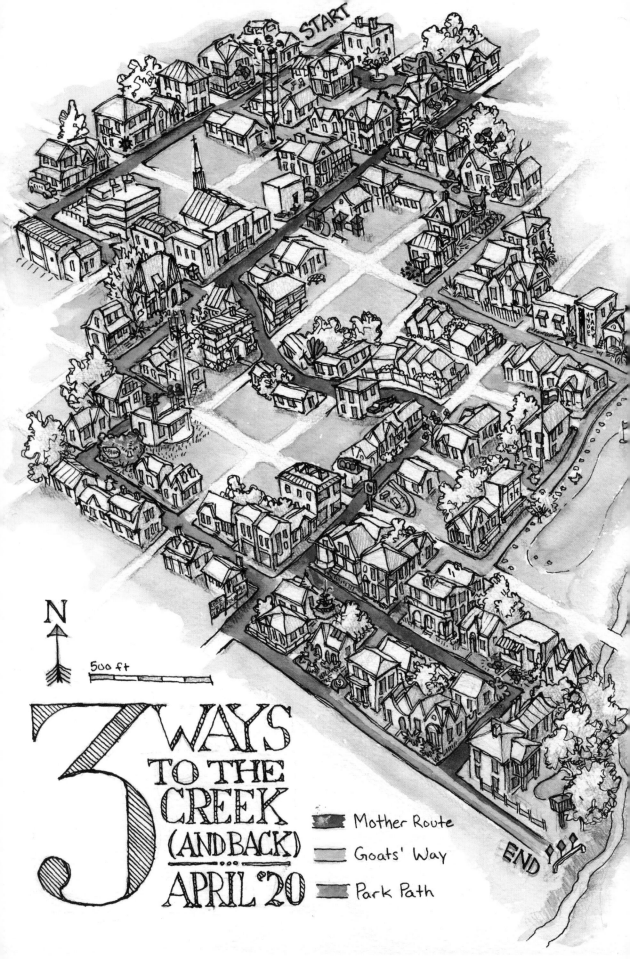

◀ **Champ Turner**, Austin, Texas, United States
My map shows a mile-long route through my neighborhood that I travel
frequently. There are dozens of possible paths, but I selected the three
I take most often. I've become more aware of the geography of my
neighborhood, both on a macro and micro scale. I've become cognizant
of the layout of streets, locations of specific landmarks, and the tiny
details in people's yards that reveal things about their lives.

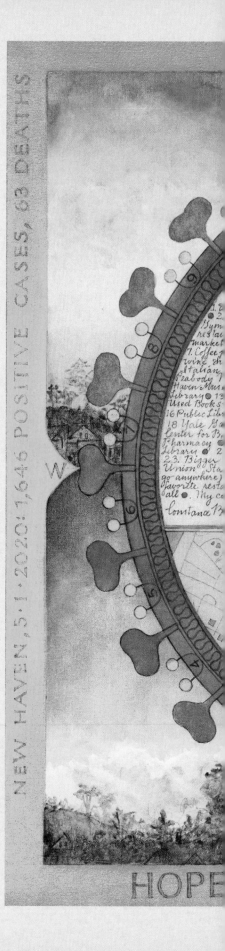

➤ **Constance Brown**, New Haven, Connecticut, United States

My apartment is located smack in the middle of the map; my New Haven perambulations radiate out from it. Behind the map I've depicted dawn and dusk from my east-facing window; perched on the edge of the corona frame is a local songbird, the yellow-throated vireo. I work at home as a mapmaker, so my work life is the same. Aside from occasional socially distanced walks with friends and telecommunication, my social life is suspended, and I miss it. I miss our local restaurants and worry about their fates. I'm grateful for our neighborhood markets and wine stores, which have stayed open. Always a lively pedestrian neighborhood, East Rock is even livelier, with walkers and runners out all the time. I'm more conscious of nature, and the new soundscape, which birds dominate. Strange to think that less than two miles away, Yale New Haven Hospital is a battleground.

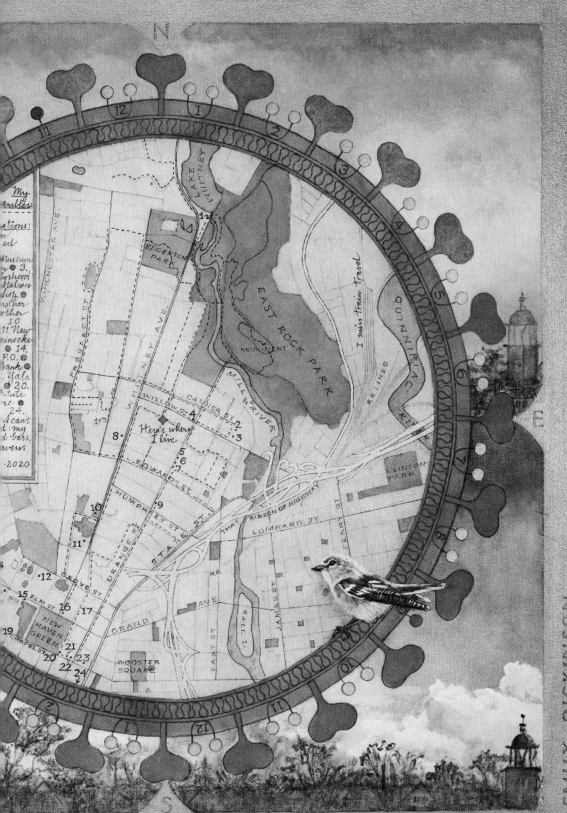

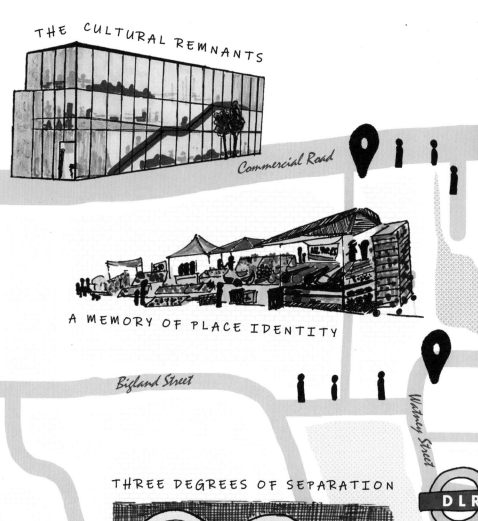

THE CULTURAL REMNANTS

Commercial Road

A MEMORY OF PLACE IDENTITY

Bigland Street

Watney Street

THREE DEGREES OF SEPARATION

DLR

Chapman Street

⊼ **Diana Dobrin**, London, United Kingdom

Putting together this map made me realize that my relationship with my neighborhood is strongly defined by several places that act as reference points in the area where I live. Although some of the places I'm most attached to, such as the local library or the street market, are now

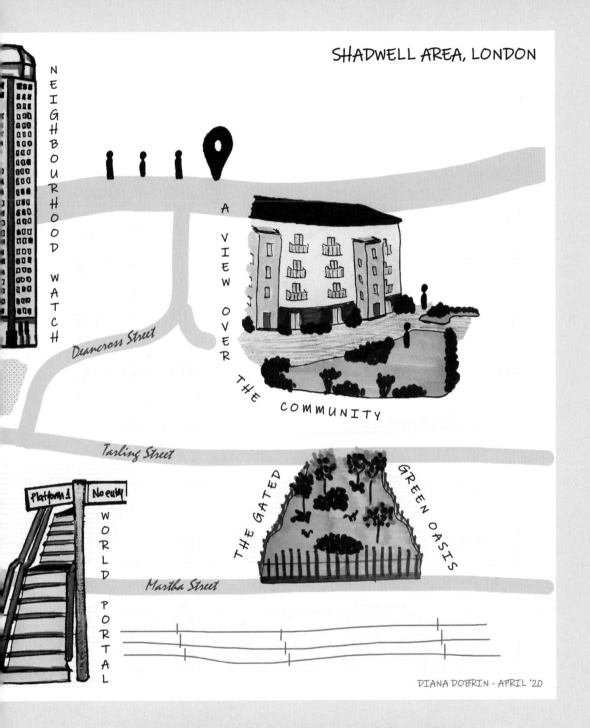

SHADWELL AREA, LONDON

NEIGHBOURHOOD WATCH

Deancross Street

A VIEW OVER THE COMMUNITY

Tarling Street

Platform 1 No entry

WORLD PORTAL

THE GATED GREEN OASIS

Martha Street

DIANA DOBRIN - APRIL '20

nowhere near their usual liveliness, they remain weirdly present in my memory. I have also come to appreciate more the views from my flat. As a proxy for any other travels, the network of streets around my place has become a welcomed geographical web for stretching and careful neighborhood mapping.

Natural Callings

With plane trips, movies, concerts, and
parties largely out of the question, wilderness
and green spaces became places for escape.
In nature preserves, city parks, and even our
own household pets, we found inspiration,
adventure, and perspective on the
smallness of the human timescale.

The Trail That
Led to Confidence

Linda Poon

The George Washington and Jefferson National Forests cover some 1.8 million acres of Virginia land. Their 2,000 miles of trails snake through lush greenery and around crystal clear waters into parts of West Virginia and Kentucky. These are my local woods, and just looking at their contours on a map moves my sense of adventure, as well as my sense of calm. I like racing up the hills as much as I enjoy meandering along a stream. I relish the feeling of standing on top of the world upon reaching the summit, as well as the humble reminder of how small I am as I walk among towering oaks.

Yet the idea of navigating any part of the forest alone had always been unfathomable, due to an immense fear of getting lost—a fear I'd never needed to confront, thanks to a network of friends who share my joy in hiking. But then the pandemic hit, and on a humid Tuesday in July 2020, I found myself driving alone to the mouth of Bird Knob trail in New Market, Virginia, a couple of hours southwest of DC.

I had questioned whether a solo trip was a wise one as I'd packed my backpack with snacks and bottled water that morning. I'd considered asking a friend to join me, but worried I wasn't up to the task of maintaining a conversation that would inevitably focus on the pandemic. That month, the US was setting records in new coronavirus cases. Amid lockdowns and heightened travel risks, summer vacation was essentially canceled. I craved an escape from my apartment and from the chaos of a spiraling pandemic and political unrest; I yearned

to breathe deeply in the stillness of nature. Compared to the uneasiness of contemplating the future, vanishing into the serenity of two grand forests for a brief moment suddenly didn't seem so daunting.

By the time I arrived, the parking lot had just one other car, its driver nowhere to be seen. I studied my notes: At 8.3 miles, the trail was much shorter than any life-changing endeavors taken by some—but for a solo trek, it was an excursion far enough outside my comfort zone. I proceeded onto the path buttressed by Virginia pines and chestnut oaks. A light breeze sent a friendly shiver down my bare arms as wildflowers and spiderwebs brushed against my legs.

The ridgeline trail remained clear enough until a couple of miles in, when I hit a fork. I knew both sides formed a loop, but as I stepped down one of them, overgrown bushes narrowed the way. I began to worry I'd wandered off-trail: There was no cell service out here to power Google Maps, and orienteering had never been my forte. When I would go hiking with friends, I'd follow their footsteps, trusting their navigational skills rather than putting any of mine to the test.

In the days before COVID-19, I had crossed entire oceans to wander unfamiliar cities, never really feeling lost when I arrived. In urban centers, it's easy to mark your destinations on Google Maps and follow the route; landmarks are clearly labeled and buildings are distinct. My life had felt much the same. I had a daily routine, and I hit certain milestones (Job promotions! Moving into my own apartment! Running my first ten-miler!) the way you pass stops on a city bus.

But the pandemic was a barrage of disorienting news. My immediate family all lost their jobs in the service industry, and dear friends were losing loved ones without getting to say goodbye. My cities—Washington, DC, and Hong Kong, where my family has roots—were deep in political upheaval, while the isolation of lockdown was straining important friendships. I was feeling more depressed by the day and burned out at work, while struggling with the guilt of even having a paycheck and a place to stay inside, when so many others did not. The well-worn path I thought I'd follow for a lifetime was now harder to make out. It was also a lot lonelier, more like picking my way through the woods without anyone to follow.

Now I kept my eyes to the ground, where I could just make out the thin dirt line defined by the thousands of hikers before me. I

reminded myself to glance up every so often to spot faint trail markers ahead. An ambiguous tip I'd found online earlier that week said to turn right at a pile of red rocks, but they were obscured by a fallen tree. I must have circled them at least three times before finally spotting their crimson hue peeking out from underneath the leaves. All the while, I trained my ears on the sound of critters and rustling trees, attempting to tune out the darker thoughts that skittered through my mind. As I neared the midway point, I began to draw a mental map of the journey I'd already made, retracing the pin drops I'd passed. The first vista's breathtaking views of western Virginia had been a reward for braving the first few miles. Farther back was that steep rock scramble I'd climbed unaided, and before that, the tree stump where I decided there was no turning back.

A sighting broke my reverie: a father and daughter in lace-up boots and baseball caps, going in the opposite direction. I asked them if I was on the right track to Emerald Pond, a beautiful swimming hole that's considered the gem of this trail. They assured me I was. I wasn't entirely alone, I realized, and most certainly not lost.

Millions of Americans sought solace in outdoor spaces during the pandemic—some of them for the very first time. Not far from where I tramped that day, year-over-year attendance in 2020 rose 14 percent at Virginia's Shenandoah National Park, and 55 percent at Catoctin Mountain Park, farther north in Maryland. Surveys by the University of Vermont found a 70 percent increase in outdoor walking in the early months of the pandemic, and that 26 percent of those visiting parks had rarely or never visited nature in the previous year. Getting turned around in unfamiliar territory is a terrifying predicament. But amid stress, the call of open vistas and rustling canopies overpowered those hesitations for many of us.

I sighted the pond; its color lived up to its name. The icy water wicked away my worries as I sat on the edge and slid my tired legs in. Could I still make a wrong turn on the way back to the car? It was possible, I thought, watching ripples form as I gently kicked at the glassy surface. But it was unlikely, as long as I focused on where my feet were taking me.

➤ **Brian Palmer**, Cape Town, South Africa
Instead of focusing on downtown Cape Town, Table Mountain National
Park, and the waterfront, I shifted the perspective to the areas near me
that tourists typically miss, namely the Cape Flats. These communities
are home to some of the most vulnerable neighborhoods in the city as
well as the most critically endangered Sand Fynbos nature preserves.
This map, watercolored into the wee hours of the morning, is my way
of shifting these values by changing how we look at the cityscape of
beautiful Cape Town.

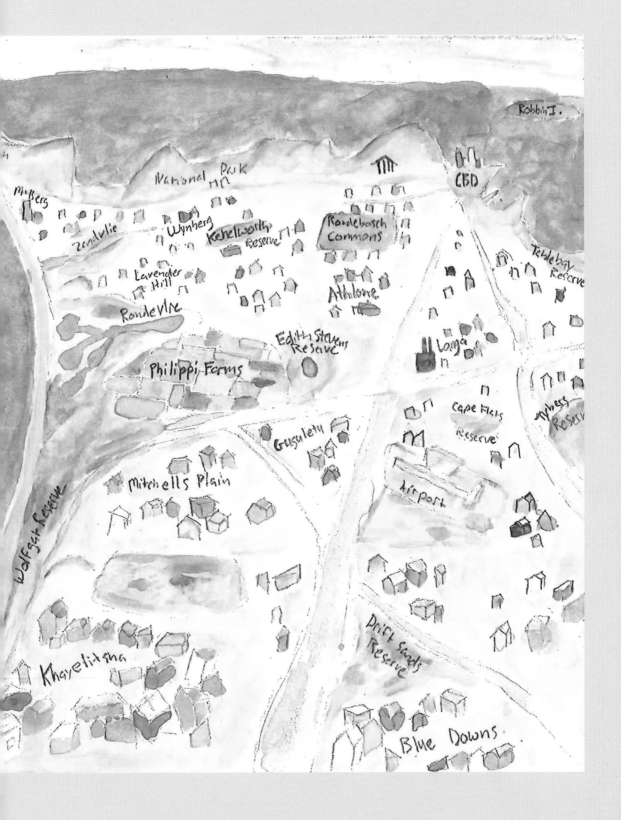

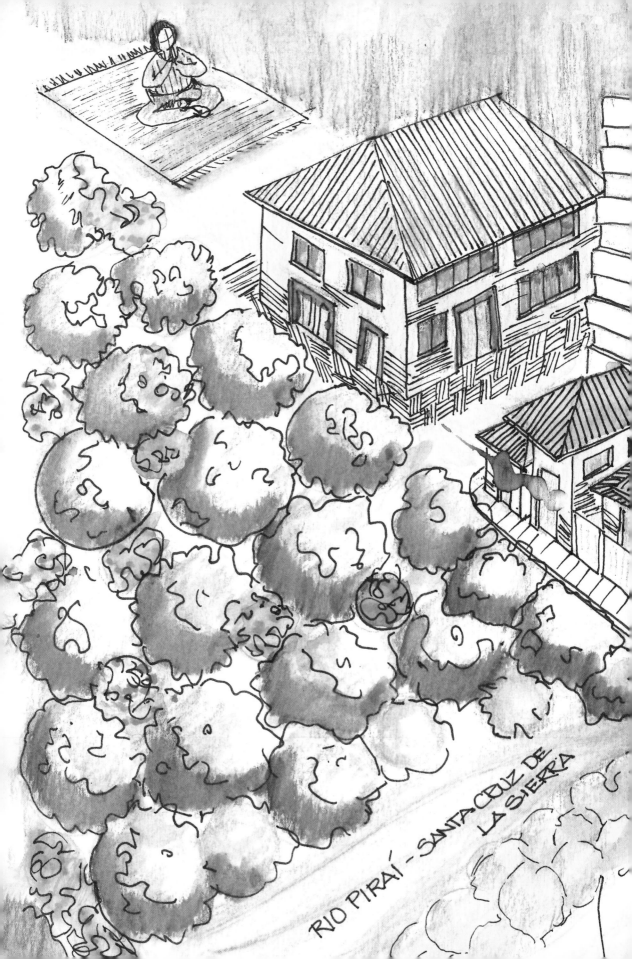

RIO PIRAÍ - SANTA CRUZ DE LA SIERRA

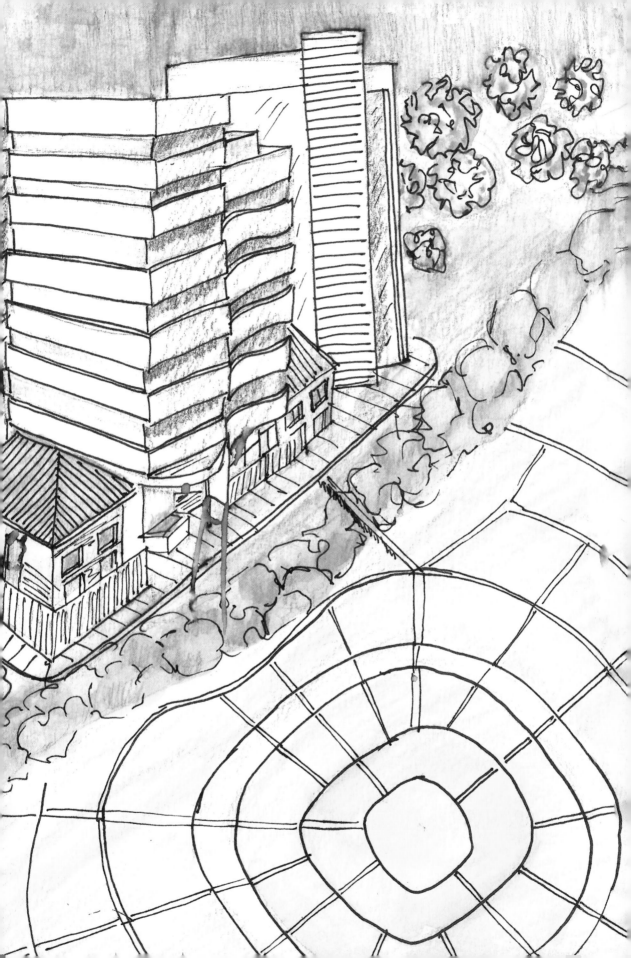

◀◀ Maria Claudia Canedo Velasco,
Santa Cruz de la Sierra, Bolivia
From my place of peace, I imagine that
the southern trees absorb the virus
that comes from the north. A lot has
changed: We communicate more, we
collaborate for food purchases, and we
are in solidarity with one another.

➤ C. X. Hua, Cambridge,
Massachusetts, United States
I drew a map of all the sounds I heard on
a long walk through my neighborhood.
My small neighborhood has become my
entire world! So things that used to seem
small now seem much bigger. Birds seem
louder. I drew this map because I found
myself listening more intently as I walked
and forming new dictionaries of sound in
my head.

map of
sounds in my
neighborhood

april 12, 2020
cambridge, MA. USA

<u>KEY</u>

birds ⌐⌐⌐ owl ⌐⌐⌐ sparrows ⌐⌐⌐ jays ⌐⌐

wind ⌐⌐⌐

chimes ⌐⌐⌐

bikes ⌐⌐⌐ ⌐⌐⌐ ⌐⌐⌐

cars ◼◼ trucks ◼◼

talking ⌐⌐ english ⌐⌐ french ⌐⌐ children ⌐⌐⌐

sprinklers ⌐⌐

dogs ⌐⌐⌐

mysterious creaking? ▲#?⌐!

WEEK 1, MID-MARCH

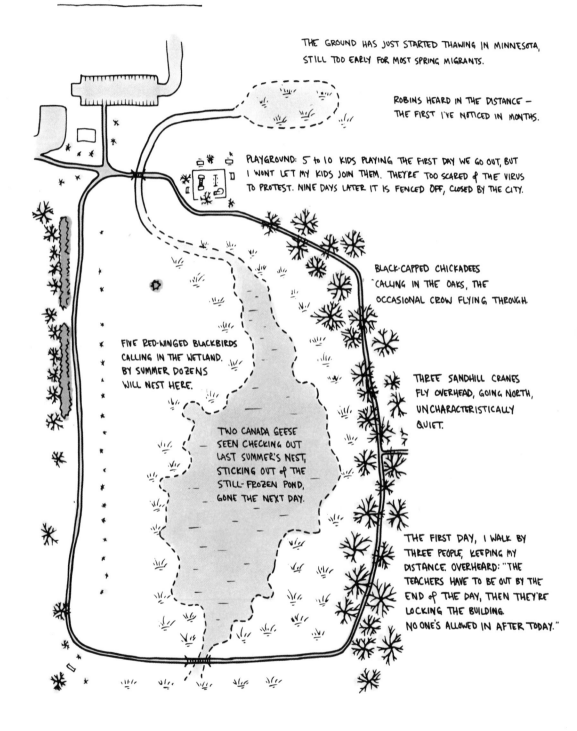

THE GROUND HAS JUST STARTED THAWING IN MINNESOTA, STILL TOO EARLY FOR MOST SPRING MIGRANTS.

ROBINS HEARD IN THE DISTANCE — THE FIRST I'VE NOTICED IN MONTHS.

PLAYGROUND: 5 to 10 KIDS PLAYING THE FIRST DAY WE GO OUT, BUT I WONT LET MY KIDS JOIN THEM. THEY'RE TOO SCARED & THE VIRUS TO PROTEST. NINE DAYS LATER IT IS FENCED OFF, CLOSED BY THE CITY.

BLACK-CAPPED CHICKADEES CALLING IN THE OAKS, THE OCCASIONAL CROW FLYING THROUGH.

FIVE RED-WINGED BLACKBIRDS CALLING IN THE WETLAND. BY SUMMER DOZENS WILL NEST HERE.

THREE SANDHILL CRANES FLY OVERHEAD, GOING NORTH, UNCHARACTERISTICALLY QUIET.

TWO CANADA GEESE SEEN CHECKING OUT LAST SUMMER'S NEST, STICKING OUT of THE STILL-FROZEN POND, GONE THE NEXT DAY.

THE FIRST DAY, I WALK BY THREE PEOPLE, KEEPING MY DISTANCE. OVERHEARD: "THE TEACHERS HAVE TO BE OUT BY THE END OF THE DAY, THEN THEY'RE LOCKING THE BUILDING. NO ONE'S ALLOWED IN AFTER TODAY."

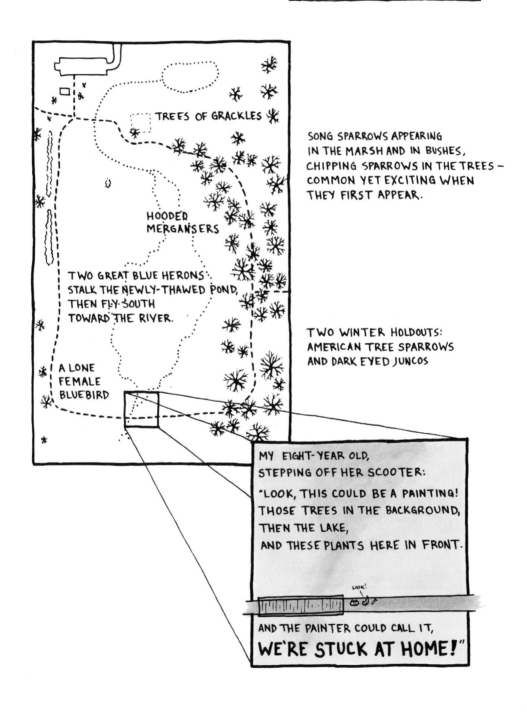

TREES OF GRACKLES

SONG SPARROWS APPEARING
IN THE MARSH AND IN BUSHES,
CHIPPING SPARROWS IN THE TREES —
COMMON YET EXCITING WHEN
THEY FIRST APPEAR.

HOODED
MERGANSERS

TWO GREAT BLUE HERONS
STALK THE NEWLY-THAWED POND,
THEN FLY SOUTH
TOWARD THE RIVER.

TWO WINTER HOLDOUTS:
AMERICAN TREE SPARROWS
AND DARK EYED JUNCOS

A LONE
FEMALE
BLUEBIRD

MY EIGHT-YEAR OLD,
STEPPING OFF HER SCOOTER:

"LOOK, THIS COULD BE A PAINTING!
THOSE TREES IN THE BACKGROUND,
THEN THE LAKE,
AND THESE PLANTS HERE IN FRONT.

LOOK!

AND THE PAINTER COULD CALL IT,
WE'RE STUCK AT HOME!"

◄◄ Richard Bohannon, St. Joseph, Minnesota, United States

Birding is being talked about as a great activity for this moment—easy to do while social distancing, gets you outside, connects you with the natural environment. These two maps are among the first in a series of birding maps I'm making as a kind of diary of the pandemic. I'm going on more walks with my kids, and wondering why I didn't go on more before.

➤ Darrell Hawkins, Canberra, Australia

With a newborn, we were always going to spend 2020 closer to home. COVID-19 further shrunk the sphere in which we lived, but it became a great opportunity to explore and enjoy that space and take my baby girl for walks among the trees and appreciate our surroundings. When COVID hit, my family and I had moved home from overseas into a new suburb on the outskirts of Canberra, where new developments intermingle with nature reserves. I began to seek out the walking and riding trails around home, while not venturing too far away, given movement restrictions imposed by government and fatherhood. I found areas marked for development, bridges that went nowhere, and some aggressive wildlife. The area is fast changing, with new developments being approved and many roads and trails unfinished or temporary. This map of walking and riding trails represents a point in time: This valley will look very different in one or two years.

MOUNT
STR

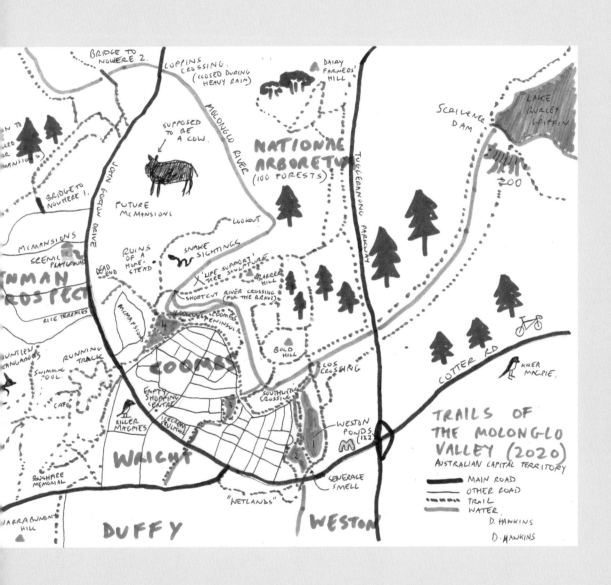

◄ **John Palumbi**, Baltimore, Maryland, United States

This is a map of our cat's nocturnal outdoor adventures during COVID-19. Ace is a nine-year-old indoor-outdoor cat who sometimes wears a collar with a GPS sports tracker. During the pandemic, he gets out a lot more than we do. As the map shows, we are experiencing our neighborhood through his eyes. Ace's range is much larger than we would have ever imagined. He "patrols" alleys; snoops in people's yards; pokes around near the waterfront; and (with fewer cars on the road) even crosses the street. While our personal "orbits" have severely contracted, our cat's has enlarged. He walks a few miles around South Baltimore every night. Ace's Adventure Map is something we look forward to each day as an antidote to our frustration and isolation. He still has the freedom to roam the city, and we don't. We envy him.

> **Justin Lini**, Washington, District of Columbia, United States
My map shows how our view of the city has become oriented along the Anacostia River. When social isolation began, my wife and I started taking many walks around our neighborhood and to nearby Kenilworth Park. Normally, people in the community don't spend much time in Kenilworth Park. There's not much in the way of things to do there, and it's a little wild and overgrown. However, it has become an oasis to us in recent weeks, as it is a good way to go for a long stroll without running into a lot of people. One thing that I've really noticed, since I'm not driving and taking the Metro everywhere, is that the natural and man-made barriers in the neighborhood have come to define the boundaries of this strange world.

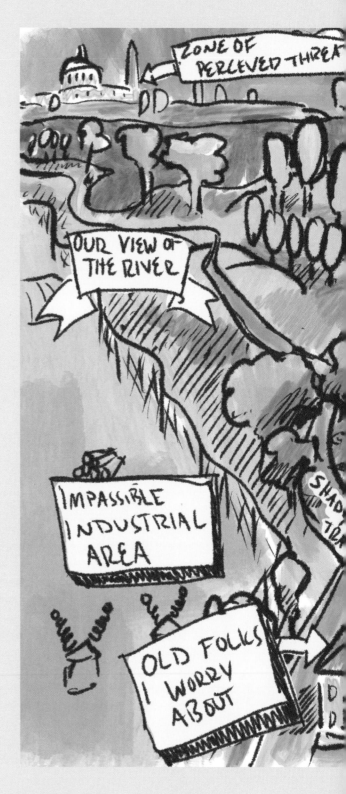

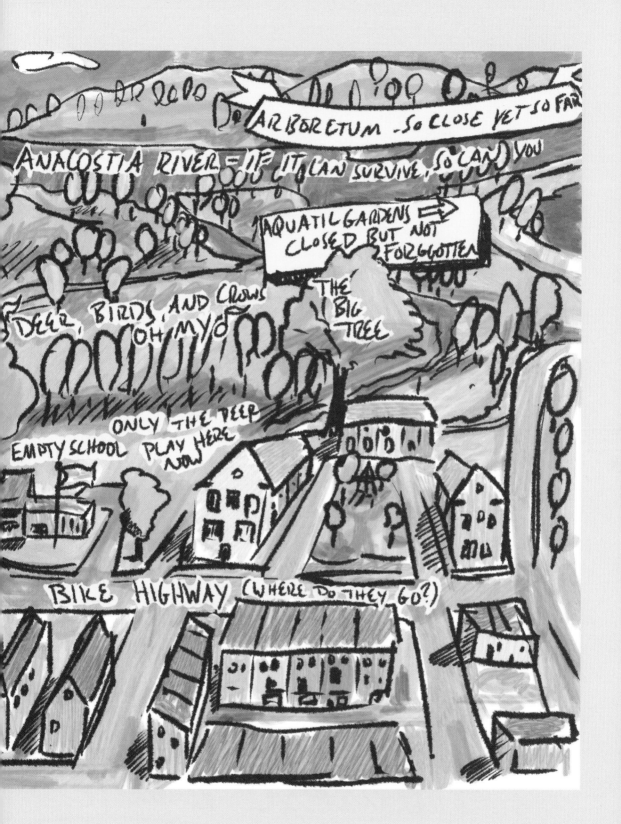

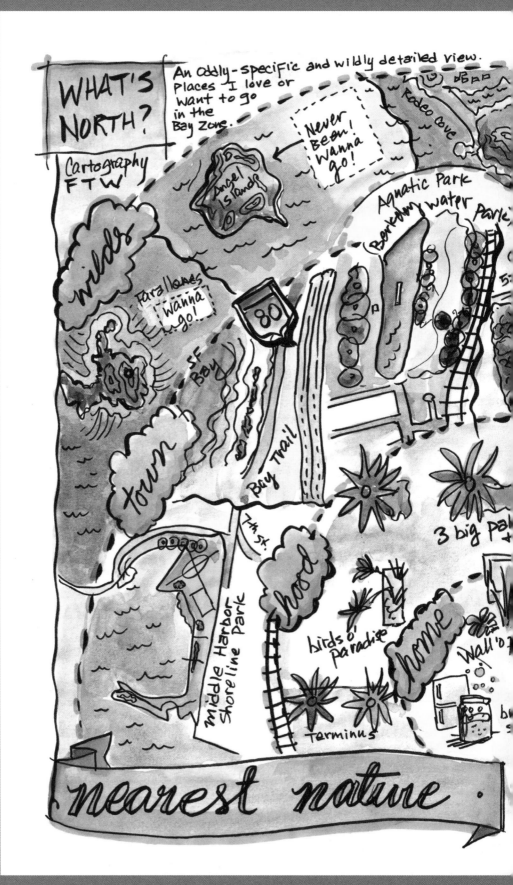

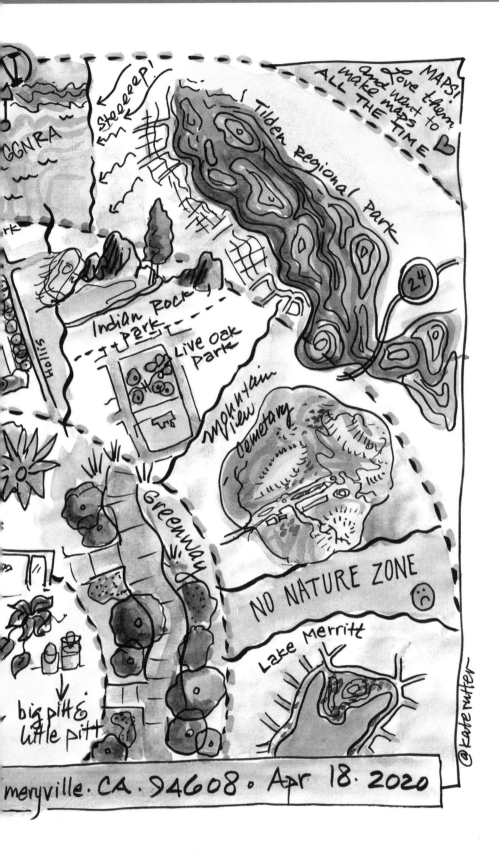

<< **Kate Rutter**, Emeryville, California, United States
Seeing nature up close and observing it with pen and paint is my most relaxing and rejuvenating activity. Usually I'm out in the world of nature. But now I must imagine my favorite places in my mind. This map was done in my home office as I captured some of my favorite nature spots from memory, starting at home and looking north. Each zone (home, neighborhood, town, and wilds) helped me revisit these places and appreciate them in a new way.

> **Lori Melliere**, Durham, North Carolina, United States
Almost the only time I leave my house these days is to take my dog, Miracle Max, for a walk around the neighborhood. I'm getting bored seeing the same things on the same route every day, but he thinks it's an adventure every time. This inspired me to create a map of our walk to the park and back—but as a pirate map from his perspective.

↑ Bondi Beach (closed!)

Mini Palm tree (my height)

Hall St

Canopy of giant figs

Mushrooms in the grass

'Bishop's Balls'! (lol)

Wellington St

Lilac bush & butterflies ♡

Smooth Gum

Globe shaped hedge @ no.

Paperbark tree
(in full bloom)

My house

O'Brien St

Grivilea
(eaten by lorikeets)

Bamboo Wall
(hiding a
modern-ish
house)

Olive tree
(end of season)

City →

◀ **Stephanie Bhim**, Sydney, Australia
For me, lockdown's biggest gift was the
flourishing of nature and the space to see
it. My map presents the magnificent trees
on my walk around the block, all different in
their shape, size, blooms, and the fauna they
attract. I am dwarfed by enormous gum and
fig trees, delighted by butterflies, enchanted
by mushrooms in the sidewalk grass. The
olive trees hearken to folk tales and distant
lands. I am uplifted by the scent of jasmine,
alerted by the squawking lorikeets, and
beckoned by the rustling bamboo. With
fewer cars and people around, nature is
more apparent to me.

Virtual Connections

As kitchen tables and couches turned into full-time work and study spaces, the internet became the conference room, library, leisure zone, and subway car all in one. Online space flattened interactions and brought distractions and worries. It also brought us together when we had to be physically apart.

Just Show Me
Where My Friends Are

Sarah Holder

The pounding headache appeared in October. A garden-variety hypochondriac, spiraling during simpler times, might have thought: brain tumor. But it was 2020. I got a COVID test—negative, but the headache persisted. I texted a friend, who suggested it was probably just a sinus infection.

On ZocDoc, I scheduled a virtual appointment. The doctor agreed: a sinus infection. *Confirmation bias,* I told myself, because I'd written "sinus infection" as a possible diagnosis in the forms I'd filled out. I called my mom. *What does he know! He just saw you through a screen,* she said. She Googled my symptoms and read aloud from WebMD. The color of my snot was all wrong. *Definitely not a sinus infection.*

I slammed orange juice, steeped tea. I talked to a therapist over Google Meet, who had told me earlier that summer, in the throes of my panic over whether to visit my parents, *It seems like you feel that you ARE the virus.* I signed up for another COVID test. San Francisco's public health department texted me a link to my second negative result. My heart started beating harder, more irregularly. Drink only the recommended dose of Emergen-C, my roommate advised. I posted a thirst trap on Instagram.

My nonstop quest for answers on the internet and its destructive interaction with my anxiety weren't exactly unprecedented phenomena. But the pandemic had managed to turn them into a totalizing force. Some people seemed to channel their neurotic quarantine energies into cultivating useful or at least charming hobbies, like being

a dedicated plant mom, visiting virtual museums, or staging Zoom plays, but for me, nothing stuck. I filled my daylight hours with long hours at work followed by long walks up San Francisco hills. And at night, I'd stalk back and forth across the internet, like a tiger in a cage. (Except imagine the tiger was actually lying horizontal on her bed, chin doubled, thumbs scrolling.)

How else did I spend those hours? Trying to make myself feel better, I guess. I clicked around IMDB, researching when actors in *Twin Peaks* were born and died. I descended into other people's Twitter beefs, and landed in niche Facebook groups about living room furniture. I stared at Facebook posts commemorating a childhood friend's father, lost to COVID. On my Notes app, I wrote a eulogy for my beloved grandmother, lost to age. Her virtual memorial service was Zoom-bombed by pornography. I served 48,000 fake customers on a game called Cooking Dash. Context collapsed; tragedy and farce flattened. I kept looking at my phone and going, "Whoa."

Such activities were not uncommon for people who, like me, were incalculably fortunate during the pandemic—healthy, employed, living with friends—as well as terrified and restless. In an article for *Wired*, Angela Watercutter described pandemic nights as an endless binge-watch of the "world's collapse into crisis," a practice that became known, mortifyingly, as doomscrolling.

There was only one small escape hatch in the labyrinth of my iPhone's home screen that didn't lead somewhere totally sinister: Find My Friends, Apple's location-sharing feature, which had long been popular among a subset of my circle. The app was simple, a map of the world flecked with blue dots that signaled "my friend!" The group that used it was mostly made up of people I'd lived with since college, or else friends that were far flung, flinging farther every year.

This use of surveillance, however consensual, was somewhat out of character for me, as a reporter interested in the privacy concerns posed by things like streetlight cameras and facial recognition technology. But to me, mutual location-sharing had always been a profound show of trust. Before the pandemic, my roommates and I would use the app to find out whom we'd come home to; discovering we were about to intersect accidentally was a thrill. Out in the world, it helped answer once-pressing questions, like: What side of the crowd are you on? Can we meet in the middle? Get back okay? Once, scheming a

surprise trip to New York, I had to plant the seeds of a lie about a busted phone days in advance, so I had an excuse to disappear from the map and reappear in a friend's Brooklyn kitchen. (On less special occasions, I didn't let it stop me from pretending I'd already left the house to meet someone before my shoes were even on.)

When things first locked down, the map was rendered basically moot. There were few meetings anymore, and no truly serendipitous ones. The flat digital distance seemed impenetrable. But as the first COVID winter drew near, I navigated absentmindedly to it more and more. I noticed that dips in the curve sparked flurries of map activity; as states loosened restrictions, I watched corner store visits turn into cross-country pilgrimages. Soon I was using it proactively to coordinate picnic birthdays and a road trip rendezvous. *Turn on Find my Sarah,* my mom instructed, when I went to Las Vegas to cover the election. My roommate camped alone in Joshua Tree, and when he re-emerged from the desert dead zone, I knew he'd gotten back okay without having to ask.

The rest of the internet was more complicated, less cozy. But it had become my whole territory. In my futile search for satisfaction, propelled by algorithmic nudging, the screen was at once the terrain I traversed, my greatest tormenter, and my constant guide. "[W]e reach for them to comfort us when we are anxious," the critic Jenna Wortham wrote of digital devices in the *New York Times Magazine,* "even though they are often the primary source of that anxiety." I tried meditation apps, but my eyes always shot open before three minutes were up. I quit teletherapy in part because I hated seeing my tearstained face reflected on screen. I tried earnestly tweeting "Depressed!" but deleted it after someone replied. I'd shared too much, with too many.

Find My Friends was an oasis. There were no case counts on this cartography of care—just the weird comfort of seeing the stacked blue dots representing my little apartment pod. It was an assurance that some of the people I cared about most in the world were catalogued and accounted for. That, as my yia-yia had put it when I was a kid, everyone was under the roof.

But much like watching forty-five Buzzfeed Tasty videos is not the same as making dinner, knowing where someone is is not the same as being with them. Compulsively checking Find My Friends couldn't

bring me lasting peace, not on its own. I already understood this, on a certain level. A few years before the pandemic, a friend in crisis had stopped responding to my text messages. For a while, I took comfort in the steady glow of her blue dot, moving dependably between work and home. The dot disappeared one day, like an abyss had opened up and taken her with it. I worried more, but soon I realized that she was still there; a few neighborhoods and a few more phone calls away. I just had to try harder. And she had to want to be found.

Eventually, I realized that's what I'd forgotten. Whatever assurance I might glimpse on the internet's horizon would be a mirage. I could sleuth out a headache diagnosis, identify Log Lady's star sign, and fry another 5,000 animated potatoes. I could forsake Twitter entirely, disconnect my WiFi, spend the rest of my days frolicking among the redwood trees. Pandemics could force me inside and online again. Uncertainty would always linger, no matter what. But I didn't have to navigate it alone.

One day in October, after I took my third negative COVID test in a week, I was visited by the friend who'd tried to assure my hypo-chondria away over text—not a pixelated simulacrum, but a real friend in the masked flesh, the one whom I had to call to triangulate, because she is too private, and independent, to consent to location tracking. We talked and walked, along the route I'd done alone so many weekends that summer, from my apartment north to Golden Gate Park; past a waterfall tinged with green dye and a herd of buffa-los and a Dutch windmill; and then, gloriously, face-to-face with the vast Pacific. We sunk our toes into the sand, there at the edge of the continent. We didn't find any answers there, only sound and spray. My head kept throbbing. We'd keep looking.

the Quarantine Commute

◄ **Peter Gorman**, Waikoloa, Hawaii, United States
During quarantine, all of the ways I interact with the world—commuting to work, going to the store, interacting with friends and family—have been compressed into a digital space. Getting from "place" to "place" is now based around my laptop keyboard. This map is a representation of my current life. Although it's frustrating to feel disconnected from my immediate surroundings, one silver lining is connecting with family and friends back home on the mainland (and all across the world).

NOWHERE AND EVERYWHERE
ALL THE TIME

I'M HERE...

UPPER WEST SIDE

CITIES IN MY MIND...

SAN JUAN, ARG

MENDOZA, ARG

BUENOS AIRES, ARG

TEL AVIV, IR

One eye sees, the other feels

◄ **Candelaria Mas Pohmajevic**, New York, New York, United States
I'm an urban design student, and being in many cities at the same time is usual for me. But quarantine was unique, because I'm nowhere and everywhere all the time. That computer connects me to the outside world. The only reminder I get of where I am is the window to the right, a glimpse of the characteristic New York City fire escape stairs and the beautiful and changing shadows in a quarantined spring.

➤ Emily Erdos, Harvard, Massachusetts, United States
A map is supposed to symbolize travel, discovery, and possibility, almost all of which COVID-19 has suppressed. I don't know what comes next, or which metaphorical life turn to take during this time of perpetual uncertainty. As a friend once wrote to me, a map has a quality of authority: Follow the directions, stick to the rules, don't digress, and you will get to where you want to go. In this time, we all tried to follow the rules, to follow the map, and yet we still got (or are getting) lost in a new normal.

But maps can encapsulate virtual as well as physical realities. They can symbolize home as much as "awayness." For me, home is a place, but it's also people. During the pandemic, those people have been spread across the globe, and my only connection to them is through a screen. So my map is a series of mini, virtual, people-centered maps. Knowing that the person behind each map has their own world and journey gives me comfort. Even more so knowing that those journeys, though currently only virtually connected, will physically intersect again someday.

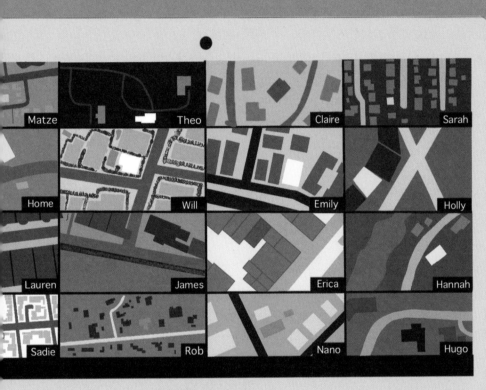

Psychic Landscapes

Sickness, uncertainty, terror, loss: Life during a pandemic was full of *sturm und drang*. Navigating the virus at work, recovering from sickness, and grieving lost loved ones were all made much harder by uncertainty and isolation. But in revised spaces and relationships, there was also hope, joy, and possibility.

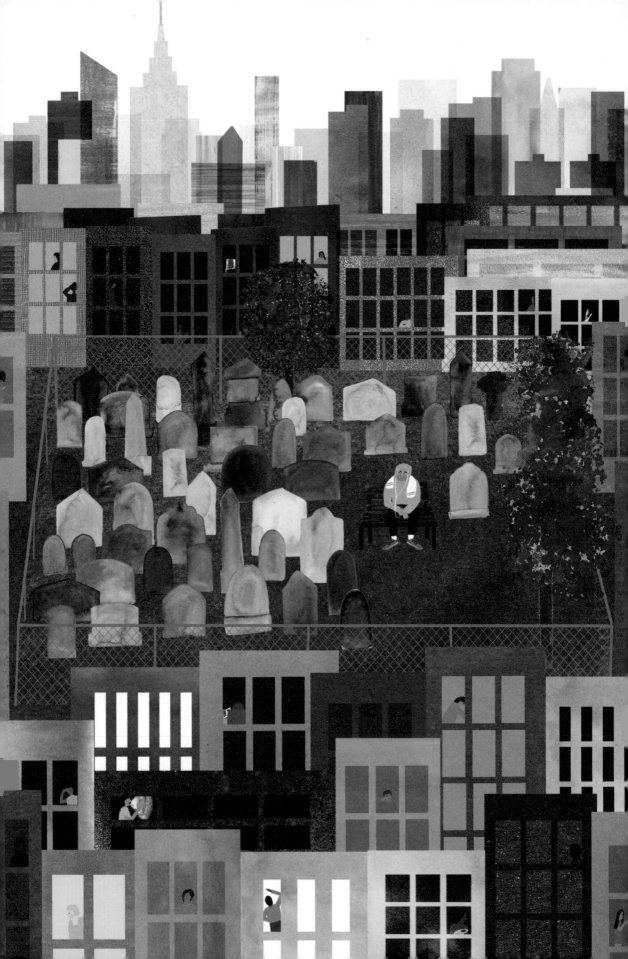

A Place for All the Grief to Go

Angely Mercado

Grover Cleveland Playground has always been a central destination for my neighborhood in Queens, New York. More of a park than a kiddie area, it's a big green space with basketball courts, a soccer field, and a splash zone, adjoining the Linden Hill United Methodist Cemetery. Despite the very visible tombstones on the other side of the fence, joggers, Ecua-volley players, and teenage couples flock to the grounds on any day temperatures pass forty degrees, along with ice cream vendors chanting "coco-mango-cherry." I started jogging there as a high schooler with my dad, doing laps around the entire block.

We'd usually start in the graveyard, hustling past old tombstones of European immigrants who flocked to New York in the early twentieth century. Sometimes I'd slow past one faded German-looking name of someone born in the 1890s, a century before me. I liked to imagine that he used to own a horse and probably took evening strolls. Nearby is a newer tombstone, which was often adorned with plastic flowers and a Puerto Rican flag. Passing by, my dad would sometimes hum or sing "En Mi Viejo San Juan," a song about someone who left the capital of Puerto Rico and was not able to return.

In March 2020, stay-at-home orders and business shutdowns swept the city, drying the steady flow of commuters out of the Seneca

◄ **Jennifer Maravillas,** Brooklyn, New York, United States

Avenue subway stop to a trickle. An old high school friend posted a meme online a few days later. "Me: planning to travel in 2020… Coronavirus: Do you mean to the park?" I laughed and shared it with friends, before realizing, grimly, that it might be a while before gatherings with any living person, anywhere, would be deemed wise. The same week, I'd lost my job as a reporter for a trade publication and moved back in with my parents. Needing space, I put on a mask and my running shoes and walked up the block, turned left at Rosemary Playground in front of IS 93, and strolled all the way to Linden Hill Cemetery, alone.

That was the start of a morning routine that I maintained as much as I physically could as my world turned upside down. During the day, my parents and sister called relatives in Puerto Rico, the Dominican Republic, New England, and Florida and took stock of cleaning supplies and masks, while I stayed inside and applied for jobs. I found myself getting dressed at six a.m. to take my solitary walks—always with gloves and a mask, always quick to panic if I saw more than three other people anywhere near me.

Doing my laps, I'd check the news. Queens, where immigrants and people of color make up nearly half of the population, quickly became the epicenter of the epicenter of the global pandemic, as the virus ran rampant through cramped apartments and places of work. Thousands of people died in the first year across my borough, far more than in whiter, more affluent Manhattan—a disparity that would play out all over the country in communities where going to work wins out as a requisite for survival over health advice to stay indoors.

In tweets, TikTok videos, and Facebook posts, I saw old classmates from school with undocumented parents, discussing symptoms and asking for prayers as relatives and friends were hospitalized. Some described lasting issues like shortness of breath or dizziness weeks after they tested negative again, yet they steeled themselves to return to jobs at restaurants, banks, and grocery stores, masked up for their commutes. And so many others were laid off and posting about needing help finding jobs. These posts contrasted with others in my feed from well-heeled influencers in Manhattan and Brooklyn taking "work from home getaways" in the Hamptons or ski towns in other states.

Somehow, the virus passed over my immediate family, but it didn't take long to touch others in my world. Doomscrolling on Twitter a few weeks into lockdown, I tallied everyone I knew who had died. The list included a relative who had planned to move back to the Caribbean before the virus spread. "Te quiero mucho," I messaged her daughter on WhatsApp, not knowing what else to say. It included my neighbor from down the block, who usually waved hello when we saw each other. Then there was the priest from church who didn't last a week before the virus killed him. My mother also showed me a video of his burial. His body was sent back home to Mexico; the funeral workers wore bright hazmat-like suits. I looked away. Isolated from family, detached from the normal communal rituals of mourning, their deaths didn't feel real to me. It felt as if they had dropped off the edge of the world, as quickly and quietly as possible.

My parents and sister and I hardly talked about all of this loss, as we attempted to keep a grip on normalcy. But it showed up in my dreams, which took on a drug-soaked haze after an emergency procedure forced a pause on my walking routine. Hopped up on melatonin gummies, ibuprofen, and half a Percocet to ease the pain of a surgical wound, one night I dreamed that all the people I knew who had died were all waiting for someone at Linden Hill. Clustered on the concrete basketball court next to the soccer field, they looked pale and sickly, like the face of a coughing woman I'd seen being carried away into an ambulance on a stretcher a few blocks away from me. In the dream, the trees near the walking trail bloomed white and pink, scattering their petals along the basketball court. I asked the dead if someone was picking them up. They didn't respond.

By the time my wound had nearly healed in early May, I had accepted a fellowship at an environmental justice news site. On mornings and evenings, I taped on extra gauze and walked past the rows of apartments on Woodward Avenue until I could see the tall, dark fence surrounding the tombstones. The flowers in the park bloomed like they had in my dream, some of the weeds had been cut, and a group of teens played soccer while their masked friends sat on the sidelines. In the summer, someone spray-painted "BLM" on the sidewalk near the entrance. The joggers came back, and socially distanced birthday picnics took over the grassy areas near the bathroom. On rainy mornings, I'd sweat under a raincoat and sit on a soggy park bench. I'd

walk to the park after arguments with my mother where I reminded her that I had initially moved out for a reason.

In October, my grandfather in the Dominican Republic passed away. Doctors tested him for COVID and said he was negative. It was just his time, one of my aunts told me. I didn't cry. I slowly walked around the park for days, ignoring the soccer players and dog walkers until I tired myself enough to sleep. I'd circle around the basketball courts and past the trees while scrolling through Instagram, looking at people on their Caribbean vacations while I was stuck in Queens, unable to attend papá's funeral. I forgot to notice how the leaves changed colors above me. I dreamed that he sat on a park bench, holding the cane he'd used when I visited for his birthday eight months earlier. "Is someone coming to get you?" I asked. He didn't respond.

It's been nearly a year since the virus first hit, and my city has changed for good. The population has decreased after people moved to escape the pandemic, mostly from Manhattan: An absence can be measured by changes in address and fewer tons of garbage pickups. But the loss from the virus itself is harder to quantify. One year later, more than 30,000 people have died in New York City's pandemic, yet I still don't understand how it all happened, or where they've all gone. March 2020 feels so far away, like a foggy, medication-induced dream that I'm trying to remember.

I'm still going on my walks, now with thicker sweatshirts. The trees are bare and spindly, like they were when I first started coming. I am still here, but some of my neighbors are not. It's soothing to dream about people who have died. But the loss from this pandemic is so vast, and the grief so neglected, I don't know if dreams can hold it. How will the rest of us mourn when we're allowed to gather again? In Queens, I imagine some of us will find ourselves back at the park. It's a place to hear, see, and embrace one another as we send off our loved ones, over the fence between this life and the next.

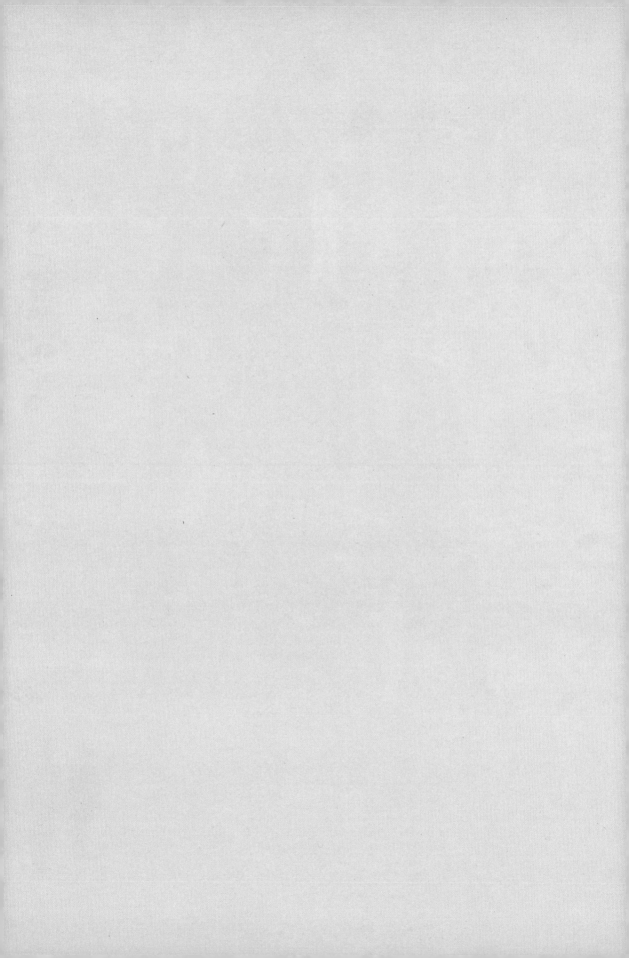

On the Front Lines
of Crisis

Laura Bliss

The acute care unit in Flagstaff, Arizona, where Mary Sharber works as a nurse, used to remind her of a grocery store or a gas station. Any person could wind up inside, be they rich or poor, young or old, Navajo, Latinx, or white. Caring for that broad cross-section of society made her job highly social.

But when COVID peaked, the hospital became more like a spaceship, where the only people allowed on board were very sick passengers and a terrified medical crew. Gone were Sharber's days of family meetings or fetching coffee for patients. The drone of newly installed particle scrubbers blasted out what little conversation was possible through the N95 masks, hooded Tyvek suits, and face shields that doctors and nurses wore to treat patients battling a disease they hadn't even heard of a few months prior. Once intubated, not everyone lived.

Those that made it through the ICU were sent to recover in Sharber's ward. Not knowing who those survivors would be left her feeling helpless and scared. "It was like there was a terrible shipwreck offshore, and we couldn't do anything to get out there and help them," she said. "Were they dying out in the water? We didn't know." The relief of seeing a patient turn up in one of her beds was proportional to that terror. "It was like they'd washed up

◄ **Jennifer Maravillas,** Brooklyn, New York, United States

on shore. We were so happy to see them—just so happy that they were alive."

Healthcare workers around the world have described the height of the pandemic in similarly nightmarish terms. And while they dealt with COVID's onslaught in the most direct and visible ways, everyone on the front lines of the pandemic—including education, food service, transportation, manufacturing, and child care—saw their workspaces transformed in other ways beyond their control. Some of them shared their stories with CityLab through oral accounts and homemade maps. Sharber's depicts her hospital as a sealed-off heart.

Jane Black, a nurse practitioner in a Tucson, Arizona, primary care clinic who is Sharber's sister, mapped her experience of caring for patients as a ribbon of viral particles that grows thicker with every bend. She labels the stages of "foreboding," "scramble," and "crisis" at COVID's onset, which give way to a prolonged witnessing of suffering, a gradual rhythm of care, and finally, utter exhaustion. "A weariness has set in as we all suffer our own infections and losses," she wrote in her accompanying text. "Care and vigilance are still needed to see us to the end of this pandemic."

David Scales, a doctor in New York City, spoke of the gulf between his experience of the COVID wave that crashed in spring 2020 and that of family and friends, who would never know what it was like to triage patients on the verge of respiratory failure with only a handful of beds left in the ICU. "There was a lot of wishing I could show someone all the places where this is not normal," he said. "It almost felt like gaslighting when I'd see people walking around as if it was."

Yet the crisis also produced new ways of delivering care. At Scales's hospital, the psychiatric unit temporarily turned into a COVID recovery ward. There, patients who'd survived the ICU received acute care along with physical and occupational therapy, psychotherapy, and chair yoga. Under normal circumstances, the financial structure of the US healthcare system made this kind of wraparound treatment unimaginable, and the ward closed within a couple of months. But for a brief period in the spring, "it was like a Shangri-La medical unit where our patients could get all the medical and physical care they needed," Scales said. His map plays up that sense of oasis in an otherwise harrowing medical landscape.

Public education was also thrown into chaos, with high-stakes battles inside US school districts and in national politics about how to return students and faculty to class. Teaching from his couch in a 900-square-foot apartment shared with his fiancée was untenable, said Noah Tang, a high school history teacher in Bloomingdale, Illinois. He fell into a deep depression when campus didn't reopen in spring 2020, and though he was allowed to return in the fall, his students weren't. Neither he nor the school itself ever quite adapted: Without kids shouting and loitering by the lockers, the motion-sensor lights in the hallways were constantly shutting off, throwing shadows on Tang's classroom as he conducted virtual lessons before rows of empty desks.

Jessica Wade, an elementary school art teacher in Prince George's County, Maryland, described a parallel experience. When the pandemic shut down her school for more than a year, the absence of a classroom haunted her. Now her students were talking heads and blacked-out boxes inside virtual conference rooms, sometimes lacking materials or quiet space that she could do nothing to provide. By fall, some students were dialing in from Nigeria, El Salvador, and other distant time zones where their immigrant families had returned to wait out the pandemic. This disintegration of walls and district lines colored Wade's dreams—the school intercom blasted in her living room; music lessons played in her bedroom. Her map portrays how "the formerly mostly distinct entities of self and school were rearranged inside my home and my mind throughout the span of virtual learning," as she writes in her description.

For Brendan Bartholomew, a bus operator at the San Francisco Municipal Transportation Agency, the job had always come with its set of stressors—angry passengers, strict schedules, harried traffic. But then his vehicle became a potentially lethal space where the virus could enter at any time. Having to enforce mask-wearing among passengers further strained his sense of safety and—when riders would lecture him on their anti-mask beliefs or why the virus wasn't real—his basic belief in their humanity. "It was exhausting," Bartholomew said. "You're negotiating for your life every single time you get on the bus, and you're negotiating with people who don't think your life has value." (Bartholomew planned to make a map for this project but broke his hand before he could.)

Louis McNair felt a similar wariness inside the grocery store where he clerks in San Marcos, California. "You can't fully trust anyone who's coming in—not that they're doing anything wrong, you just never know where they're coming from," he said. He tried to stay in the back of the store with coworkers, whom he trusted more. Eventually he was promoted to lead clerk. But his life's momentum halted in other ways. The pandemic hit just two months before he graduated from college. With classes going remote, he communicated less with fellow students. A javelin thrower, his last track meet of his college career was abruptly canceled; he remembers his teammates crying.

How will the lives of these workers be permanently changed by COVID, and what about their relationships to the places they work? Sharber said that her colleagues bonded through the crisis, and that they now work better as a team. But the entire healthcare profession is burned out. "The pandemic has made people question how much longer they want to work in a broken system, without making it possible to care for patients in ways they need to be cared for," Scales said.

As educators, Tang and Wade both said they now place greater value on physical location. "I've realized that a classroom is not just the four walls that enclose us—it's also the interactions we're supposed to have," Tang said. "I see it as much more of a sacred space." And while Bartholomew feels safer having received the vaccine, he suspects that COVID could forever taint his perception of passengers: "Will I always wonder if they were one of those people who refused to wear a mask—who'd behave like my life does not matter?"

McNair isn't sure yet what course his life will take post-pandemic. His map shows how the commute to his grocery gig became a landscape of worry, fear, and stress, as he balanced final exams, work, and the loss of social connections. A year later, he said those feelings haven't gone away, and that a lot of his friends are also struggling with mental health. The wide open green spaces where he used to practice with teammates still aren't open. He said he dreams of being able to throw a javelin again—"for the powerful feeling you get, and for seeing how far it can go."

REPEAT

BREATHE IN
BREATHE OUT, ON A SINGLE
 LONG NOTE

SYLLABLE ACCORDING TO CHART,
FEEL THE NOTE VIBRATING
IN THAT PART OF BODY

PICK PITCHES, LOW TO HI
 IN YOUR RANGE

LOW FOR GUT THEN
UP TO HIGHEST NOTE AT HEAD TOP

◄◄ ► **Anna Roberts-Gevalt**, Lenapehoking/
New York City, New York, United States
March 30, 2021, marks a year of being sick with
long COVID. I think I probably got it at the grocery
store, before we were all wearing masks, but
were sanitizing all the food. My life moves to the
tempo of fevers, fogs, aches, and moments of
relief. Moments of grief. Bed mountain is the most
prominent geographical feature.

The map shows other fragments; it is
incomplete. Finishing is not always possible with
this fatigue.

A lifeline is six others who are sick; we meet in
the mornings when we can, sharing complaints,
care, encouragement. A lifeline is occasional
moments of deep presentness—one way to get
there is this singing exercise on the map, taught to
me by Meredith Monk. A lifeline is hours of tuning
out, when the pain is too much to look in the face.

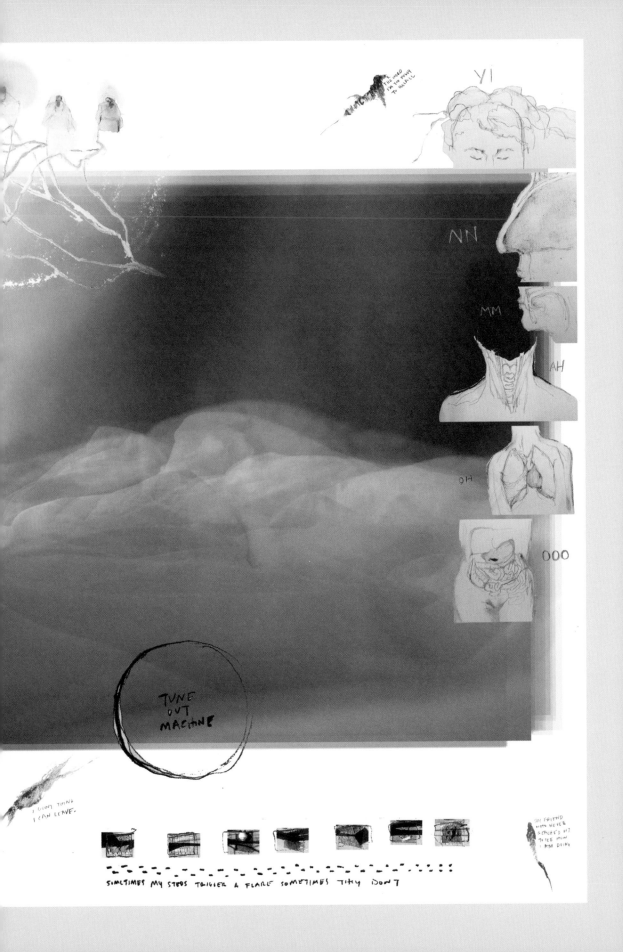

◄ **Louis McNair**, Carlsbad, California, United States
My map begins with my almost daily drive to work in a grocery store, shown in the thick black line. There are words, feelings, topics all over that represent what has gone through my mind during these times. As the words descend they go from color to black and gray, and the colorful neat words slowly transition into gray messy words.

> **Noah Tang**, Bloomington, Illinois, United States
This map of my currently empty high school classroom is for the custodians who need to know where the desks are placed when cleaning the floors over the summer. Usually I would have to draw this map at the end of May, but with school closures, it happened earlier this year. I could not say a proper goodbye to my kids. No matter how stressful teaching in person was, I really cherished the human and face-to-face interactions. However, as a history teacher, my students and I now truly feel how it is to live through a massively historic event.

MPTY DESKs

FRONT

TEACHER'S DESK FILE FILE

➤ **Jane Black**, Tucson, Arizona, United States

My map is from my perspective as a nurse practitioner in a primary care clinic. The map begins with the onset of the pandemic, waiting to see what was going to happen. As the virus spread, healthcare providers were making decisions based on rapidly evolving information. The pandemic hit the crisis point with infections and deaths mounting, and patients suffering fear, insecurity, illness, and loss. Gradually, the medical community has learned to care for COVID patients more effectively, but a weariness has set in as we all suffer our own infections and losses. Care and vigilance are still needed to see us to the end of this pandemic.

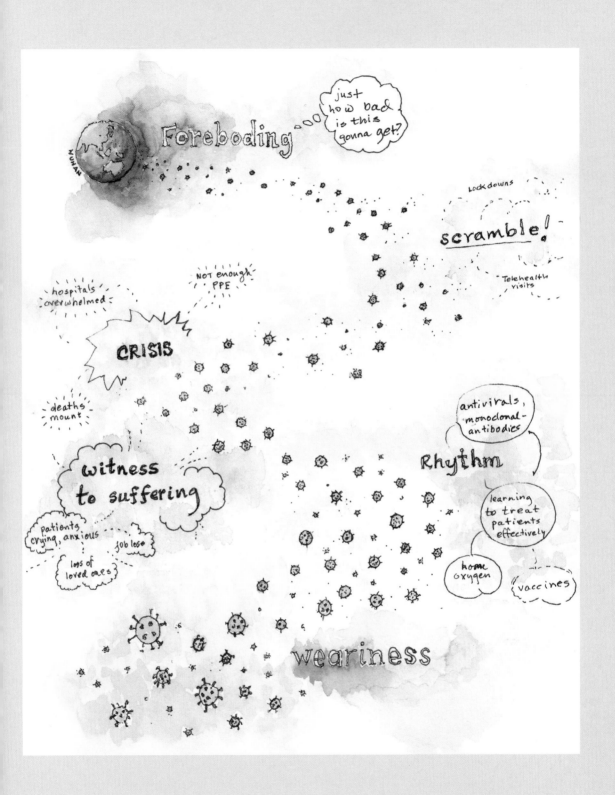

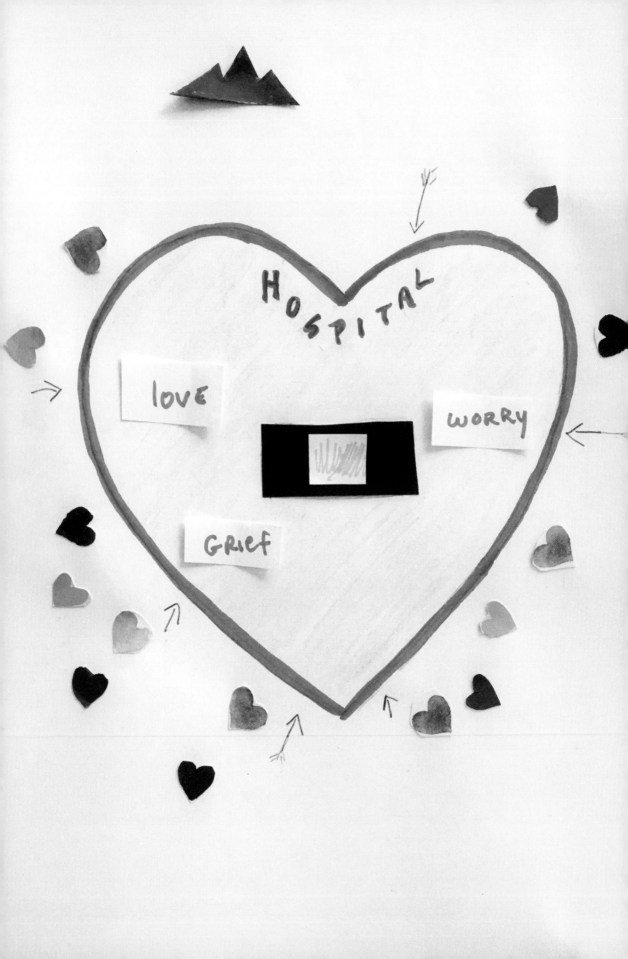

◄ Mary Sharber, Flagstaff, Arizona, United States
This map is about my experience as a healthcare professional during the pandemic. I work as a hospital bedside nurse in a city in northern Arizona, adjacent to the Navajo and Hopi reservations. The blue mountains are from the Navajo flag, representing the peaks north of the city, and the southwest corner of their land. I chose that emblem because over half our patient population is often Navajo, and they were badly hit by the coronavirus.

I drew the hospital in the shape of a heart to represent my emotional and intellectual experiences working in the center of the pandemic crisis, especially during those first months when so little was known: love, caring, intensity, and urgency. The whole hospital organization was focused as one with nonstop energy on the virus; everything else was secondary. All our usual procedures were in rapid flux, sometimes changing daily, as new needs, helpful strategies, or information emerged. I pointed the small hearts and arrows toward the hospital for the gigantic stream of care, gifts, and support flowing in from every conceivable source just to help in any way; we were all united. The COVID ICU is at the center of the heart. It felt like a black hole; the doctors and scientists were still trying to understand the disease, people were dying, we had no idea if anyone would ever make it out, we were so sad, and we wanted so much to help. When we got the first patients out of intensive care to our floor, we were so grateful and happy to see them! It was as though we had been watching from shore out to sea where we knew there had been a terrible shipwreck, out of sight; we couldn't reach them to help, and now some lone survivors had made it to shore, washed up on the beach, barely alive, and we could finally take care of them.

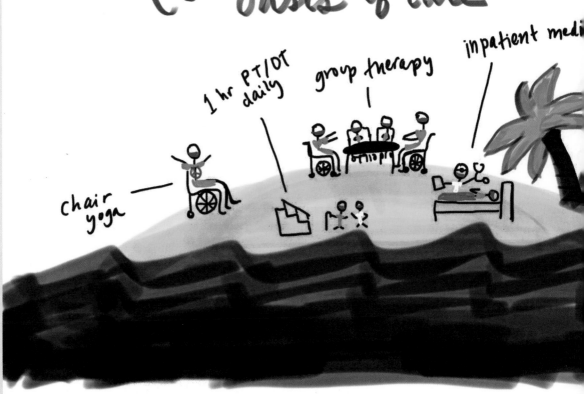

◄ **David Scales**, New York, New York, United States
In our health system, in which providers are parched and patient services are desiccated, the COVID Recovery Unit was an oasis. We had readily accessible specialists, enough physical and occupational therapy for our patients to learn to walk and get closer to normal life. We saw them physically and mentally improve while in the hospital, the CRU giving us a glimpse into a health system that could provide so much more for patients and families. A care system that offered more than just medical services but multidimensional psychological care, from meeting with neuropsychologists to group therapy, chair yoga, and meditation. After watching so much death early in the pandemic, to intubate patients or watch their hearts stop, then, two months later, see those people walk the hallway saying, "Buen día," provided a salve to heal some of our traumas and provide a glimmer of hope that this system that failed so many can, at its best, provide so, so much.

➤ **Jessica Wade**, Takoma Park, Maryland, United States
As an elementary school art teacher in a large public school system, I have spent the last year learning to reach my six hundred students via video conferencing. So in thinking about how to describe this experience in map format, I immediately visualized the iconography of Zoom. The world of education has been both enabled and invaded by grids of black video boxes, which all teachers look at, all day long, during virtual learning. While this interface has provided a way for education to move forward during the pandemic, it also represents an invasion of private space. In this map I have tried to show how the formerly mostly distinct entities of self and school were rearranged inside my home and my mind throughout the span of virtual learning.

As we all slowly move back toward our physical school buildings, I am aware of the emotional toll on teachers as well as on students (is it any wonder so many of them choose to have their cameras turned off?), of having carved out public spaces inside our homes, with the additional expectation of our presence on class recordings that are used by any students who missed live class. At the same time the peek into so many students' homes put teachers, as mandatory reporters, on a new level of vigilance for anything concerning that we might witness on video. All of this is much more exposure than anybody signed up for, so while going back to physical school has many challenges, it is a relief to dismantle the one-room virtual schoolhouse that my sons and I have shared over the last year, and to feel this mental space opening up again.

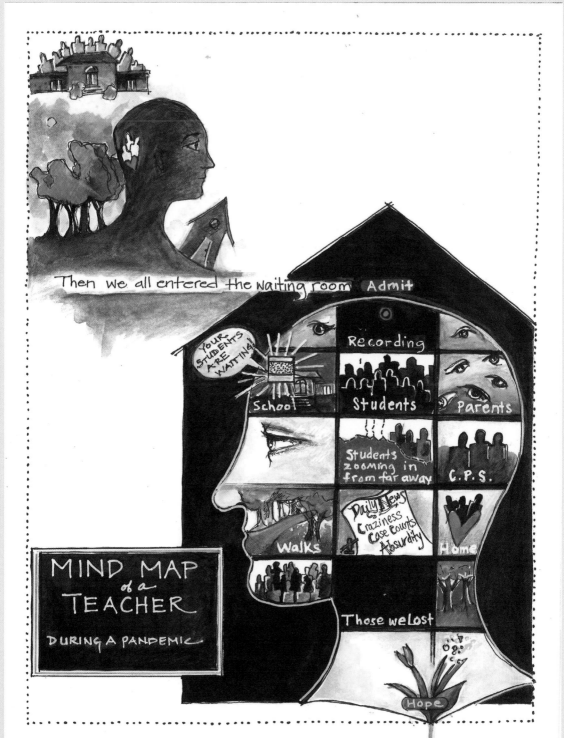

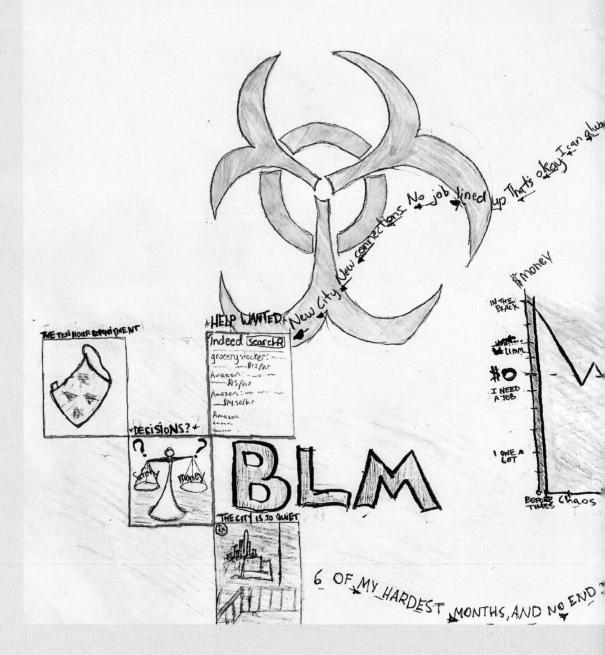

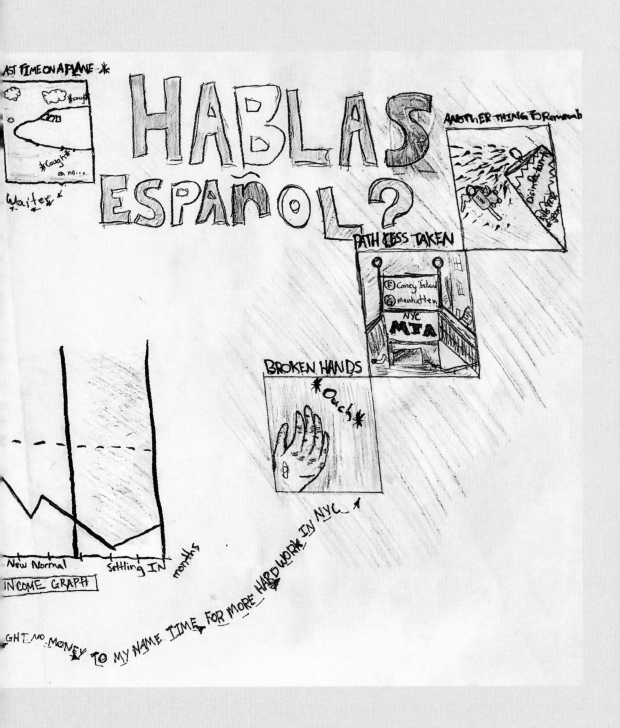

<< **Jacob Harrell**, New York, New York, United States

This web of images represents my journey as I moved across the country during the pandemic. The images display daily encounters while working (or lacking) an essential job during this time, from the primarily Spanish-speaking commuters, to my daily activities that involved being COVID-conscious. My income graphic and lines of thought between groups of pictures help quantify my life's rapid change and uncertainty, which many times was unknown or unreliable at best. I've had an interesting rise, fall, and slow climb back to where I started.

The titles given to most of the images speak to how the pandemic affected everyday practices that may have been previously taken for granted or unconsidered. "Broken hands" is a nod to the types of work that require in-person labor versus work that does not. Because of my work as a mechanic, my hands are often raw, cut, burned, dirty, and generally covered in scars. Some weeks are better than others, but they are usually injured in some way. My hands tell that story and, perhaps because I also have sleeve tattoos and am a person of color, strangers often make assumptions about who I am. I'm not often the target of panhandling or any of your average city trouble due to my hands being on display.

> **Susan Sullivan**, Petaluma, California, United States

I am a ceramic artist and have concentrated on making ceramic "maps" the last few years. For me, maps are pictures of how we move through the world, mentally and physically. The pandemic had a clear impact on us, especially since we had barely settled down after moving from our home of 40 years to a new place. We had begun to engage in activities, classes, volunteer work, and building a new studio. When the shelter-in-place orders arrived, all this came to a sudden halt. We were grateful for our garden, studio, and neighbors, but it still felt strange. Then the wildfires came, and we were pushed into an even smaller world inside, with the air unbreathable outside. It took effort some days to feel gratitude, but the whole pandemic has been an opportunity for gratitude, patience, resilience, and appreciation. I never thought I would be longing for a simple thing like meeting a friend for coffee in a restaurant. In the future, I hope I can still feel appreciation for the little things the way I do now.

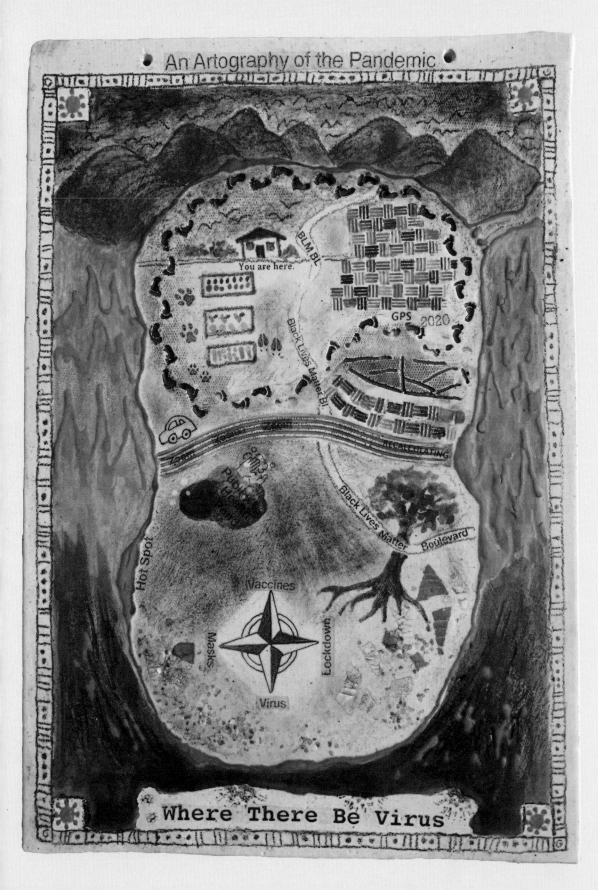

2,680mi

Legend:
♥ - college (where I should be)
♥ - hometown (where I wish I was)
♥ - home (where I don't want to be)
• - Someone I have talked to in quarantine. Someone I miss.
〰 - treacherous, infected land keeping me away from those I love.
∫ - flights I'm desperate to take

1,582 mi

<< **Marta Petteni**, Portland, Oregon, United States

I am an Italian who has lived in Portland, Oregon, since 2017. My hometown, Bergamo, was devastated by COVID-19, while in Portland, the situation is (or at least seems) better. My family and friends in Italy often share with me the ways that they are suffering from enclosure and the outdoors that they are missing. Often, while walking toward the park, I dream that I might turn the corner and find my Italian home there. It is a small yellow house with a grassy garden, an olive tree, and big windows. My parents are reading in the sun, and my sister is waving at me, ready to join the walk. Even if the pandemic has made physical distances more painful, in my heart, my beloved worlds are even closer.

< **Ezra Silke**, San Diego, California, United States

This is a map of the United States, as defined by where my friendships are. I just moved to San Diego and have no attachment to it as a city. The cities I'm attached to are thousands of miles away from me, and I dearly miss the people in those cities. Quarantine has shrunk my world to just my house, but at the same time has reminded me that my world is much, much wider, and my connections span not only the country but the globe. Now, due to self-isolation, I will not have the chance to explore the neighborhood or surrounding areas. I will not get to know the people. I will stay inside and talk to the people I already know. As such, my neighborhood has grown to ignore all state borders and has become the people I loved before this crisis.

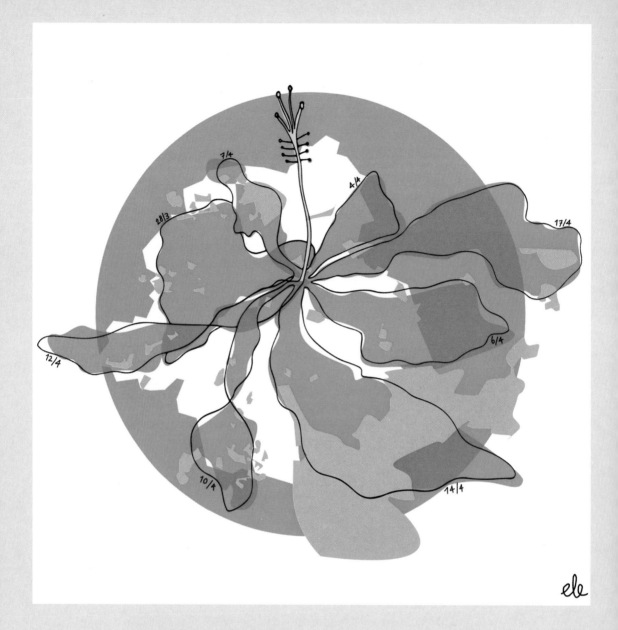

▲ **Ele Denne**, Brussels, Belgium

My first map is a hibiscus flower, representing the blossoming trees, made up of the different bike routes I took in April 2020 around Brussels. I also included some parks of the area to show the unequal spatial distribution of green spaces. This inequality became more acknowledged as an issue during the first weeks of quarantine, when the police sent someone who was taking a walk back to their own neighborhood, one without many green spaces, even though there were no official distance limits.

In summer, I dated a train conductor. To promote tourism within Belgium, it was free to take your bike on the train, so I would bike to

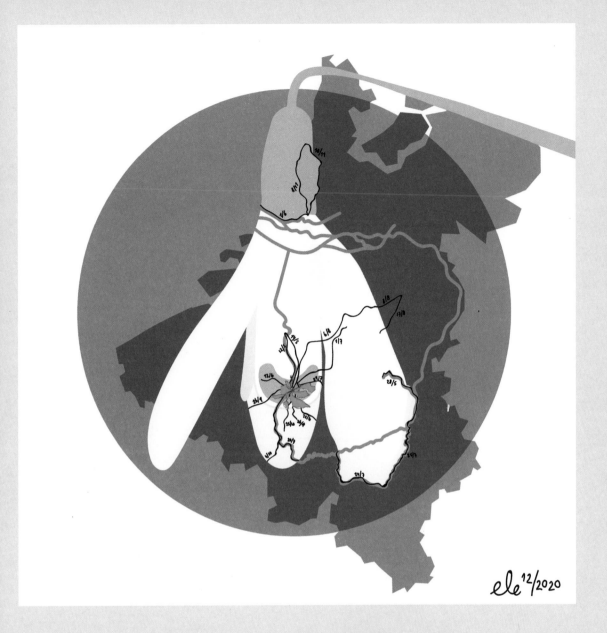

ele ¹²/2020

random stations to catch his train and go back to Brussels together. I also biked to the Netherlands! These one-way rides don't really create the shape of a flower, though, and unfortunately, my 2020 was also defined by loneliness and loss. I lost my twenty-six-year-old cousin to suicide in July, and in September I found out that my grandma—my idol and my only family in Belgium—has cancer. The snowdrop is not only the birth flower (January) of both my cousin and my grandma, but she also symbolizes hope for people going through tough times, as one of the first flowers to bloom in spring. I can't wait.

Petulant hands crawling away from their legs

A great smiling yellow squash wobbling on a tree branch by the side of the road excellent

Squashed fagpost

A very colourful flower where there shouldn't be one

<< **James Crossley**, Athens, Greece
I spent most of the year strictly locked down in Athens, and when I eventually left and cycled through Greece and Italy, I was hyper-aware of all signals of humanity. Evidence of a certain mischievousness seemed to connect me to the places and people I was riding past: a curvy squash that someone had hung in a tree on the side of the road, an oven with a plug for a hairdryer, a bottle stuck on top of a pole. My map charts 2020 through this playful view of humanity.

> **Jean Farley Brown**, Chicago, Illinois, United States
My map shows the painful isolation of my mother, who is a recent widow with worsening dementia and various other maladies of old age, and who is living in a long-term skilled nursing facility. During the pandemic this year, mom survived a painful and miserable bout with COVID-19 and has at times been confused about the virus, the restrictions, and her community. I cannot help my mom. She is afraid much of the time, and it is agonizing to be unable to hug her and sit by her side. Meanwhile, my life has gone on. It's been more limited than usual, but in comparison I've had freedom to go on living. I am lucky to be healthy and working. I've had joy in my day-to-day living. But the death of my dad and the dismal life my mom is living have been torturous. They did everything possible to plan the ends of their lives comfortably and safely, and it's all been cruelly upended.

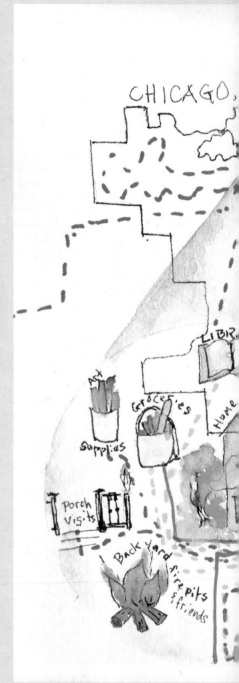

Heartbreak 2020

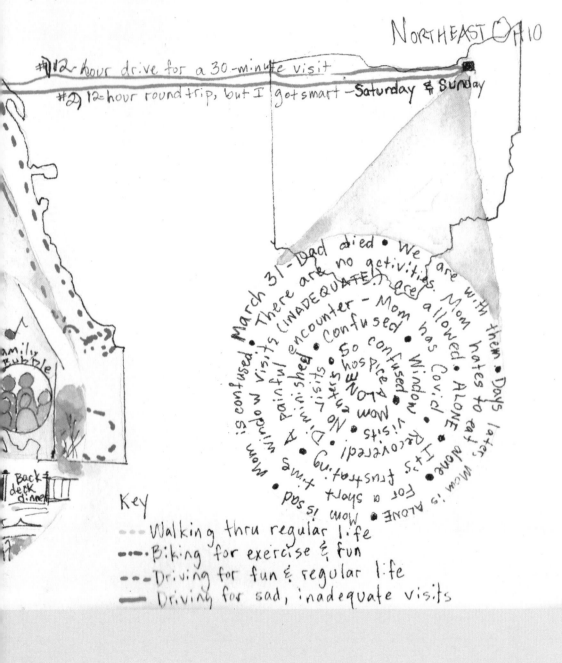

NORTHEAST OHIO

#1 12-hour drive for a 30-minute visit

#2 12-hour round trip, but I got smart —Saturday & Sunday

Family Bubble

Back deck dinner

March 31 - Dad died • We are with them • Days later Mom is confused • There are no activities. Mom hates to eat alone • Mom is confused • painful visits (INADEQUATE. I ace allowed • ALONE • For a short time window visits encounter — Mom has Covid. Mom is ALONE Diminished visits • Confused • Window Recovered! It's frustrating. No visits • visits Mom is sad 50 confused hospice enters ALONE Mom

Key
--- Walking thru regular life
•••• Biking for exercise & fun
- - - Driving for fun & regular life
— Driving for sad, inadequate visits

Social Change

With millions sick and dead, and economic
inequalities deepened, the pandemic both shook up
and reinforced political and social orders all over the
world. It also inspired visions for a more just future.

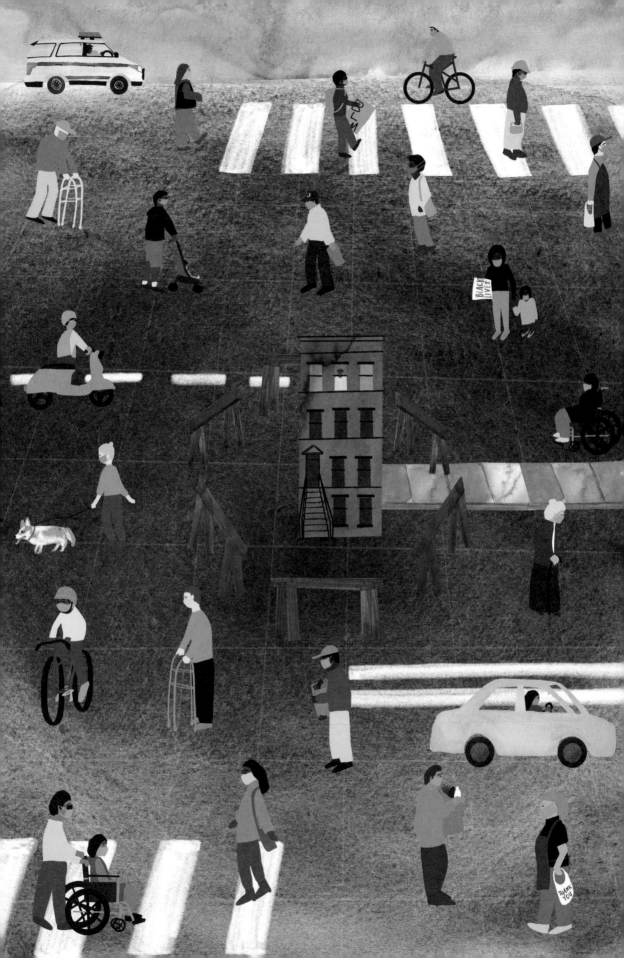

The Pandemic Made Me an Un-Urban Planner

Dr. Destiny Thomas

On May 5, 2020, I woke up to text messages from friends urging me to stay off social media. I did my best to avoid it throughout the day, but I put the news on TV in the background while cooking dinner. As I rotated the plantain in my skillet, I froze: I'd just heard a man take his last breath.

Ahmaud. I'll never forget the image of him lying in the middle of a hot road in Georgia, having been hunted and killed by white supremacists, or the way my body filled with rage at the sight of it. In the weeks and months that followed, I was haunted by the fact that Ahmaud Arbery had lost his life more than two months prior to that moment, and I'd spent much of that time debating online about what to do with "urban space."

That was because of the way many cities responded to the pandemic in its early months. Places like Oakland, Minneapolis, Seattle, Washington, DC, and beyond moved swiftly to restrict cars on miles of residential streets, with the stated intention of "creating space" for walking, biking, and socially distant recreation. Never mind the mixed messages of these cities simultaneously closing parks, reducing transit service, and ordering people to stay inside. The "ban cars"

contingent, an active crowd on social media, heartily acclaimed these policies, leaving me feeling more alienated than by the experience of long-term social distancing itself.

While cities were being crushed by the economic fallout and death being caused by COVID-19, my Twitter timeline devolved into an urbanist crusade—a street-closure cheering section that ignored the public health crisis overtaking Black and brown neighborhoods, as well as the history of racist urban planning practices. Cities that had reputations for redlining, racist housing covenants, and catering to real estate speculation became celebrated active transportation superstars overnight. While food pantries emptied, intensive care units in Latinx communities overflowed, and refrigerated morgue trucks lined the streets of Black neighborhoods, the spotlight of the transportation planning world was fixed on city officials who doubled down on their love for slow streets and car bans. Other Black urban planners and I asked colleagues in government and nonprofits to hold off on changes that could be disruptive to neighborhoods hit hardest by the pandemic. Yet they bragged about the street closures, going on Zoom panels to talk about the pandemic as an "opportunity" to streamline a permanent planning shift.

I found myself confused by the tone and spectacle of the discourse. Nobody seemed to notice that these car-ban debates actually centered cars. Just as in the streetscape, there was little room left to plan for or talk about the actual people being impacted. On walks, I started to notice large boulders and spikes along walls meant to deter unhoused people from seeking shelter. I saw massive parking lots in front of closed gyms and salons roped off with caution tape to keep people from sleeping in cars or using parking lots recreationally. While planners, engineers, and bicycling advocates morphed into work-from-home Zoom commuters who debated about how well they were social distancing and how to accessorize their new indoor realities, they were simultaneously signing off on policies that intensified the worst kinds of social erasure—surveilling the poor, restricting freedom of movement, and stripping away dignified shelter options. These actions prioritized urbanist ideology over actual justice—a violent form of territorialism.

As an urban planner and as a Black woman born and raised two blocks away from an abandoned military base full of radioactive

waste and toxic soil, I understand and wholeheartedly agree that planners should act quickly to help heal cities from generations of toxic industry and environmental injustice. I see the connection between cars and this place-based harm very clearly: Fewer cars on the road would mean less exposure to carbon dioxide and other greenhouse gases directly linked to climate change and health disparities. My frustration with my peers was that an *actual* opportunity to begin these healing processes was willfully overlooked. Colleagues whom I'd assumed were like-minded and shared my values replied to my Twitter posts proclaiming their rights to the outdoors and criticizing what I believed to be basic, valid inquiries: *What if we give free bikes to residents in low-income communities? Would closing streets to cars impede medical services, mutual aid deliveries, and other essentials? Have we considered the fact that essential workers are likely relying on cars to get to and from the jobs that are keeping the rest of us alive?*

These painful contradictions came into sharp relief after Ahmaud's death. Those on social media who equated the absence of cars with what they called "safe streets" had hardly any comment or condolence to offer a Black man whose life was taken as he jogged through an empty avenue. I went four days without sleeping. I could not reconcile in my own heart and mind what to make of an industry—one that literally builds streets—so intent on reclaiming space that it would willfully ignore the ways that same sense of territorialism equates to the dehumanization and murder of Black bodies. The irony struck me profusely.

This caused me to see space differently. As 2020 went on, I grew to resent the idea of going outside. I refused to perform "active transportation" in any way that would cause me to be seen or tokenized as validating a set of urbanist politics that failed to care for my safety and well-being in the outside world. I remember finding a bike path I hadn't noticed prior to the pandemic and having mixed feelings. I was excited because, after all, I'm a transportation planner—I want to see people be able to ride bikes. But I was also viscerally upset at the thought of the number of people who would cycle or jog that path without ever having to consider who didn't have safety and access on it.

On May 10, I resolved to reconcile this inner conflict by running 2.23 miles each day in remembrance of Ahmaud—February 23 had

been the day of his murder. Ten seconds into my first run I cried and sat in the shade for hours. How is everyone so excited to be outside when being outside only reminds me of trauma? That day was the last recreational walk I took in 2020. I decided I'd rather sit in isolation than be gaslit by an entire sector that can't understand why Black people have such a tumultuous relationship with navigating space. And then we entered what felt to me like a never-ending season of mourning the deaths of Black people who were failed by many systems and institutions, including urbanism.

It wasn't just the gaslighting in the planning sector or the strain of social distancing that made 2020 difficult for me. It was that gathering, protesting, spiritual rituals—go-to lifelines that make up my personal sense of home—were off limits to so many of us who had to remain socially distant during the pandemic. Similarly, my work no longer allowed for the in-person meetings essential to my practice of community engagement, participatory policy-making, and anti-displacement programs through face-to-face coalition building.

So, in 2020, I ended my relationship with the title *urbanist* and became an *un-urbanist* instead. I recommitted myself to actively working to disrupt what I consider toxic urbanism, which is not just the literal toxicity of the climate, or the disparities, disasters, and public health crises. It's the sector's disinterest in comprehensive intra-community planning, and unflagging orientation toward white people's preferences. I started my own business, which provides strategies and community engagement services in the interest of racialized people, using an interdisciplinary, anti-racist, dignity-infused approach to urban planning. There, I lend my creativity to reimagining the ways transportation planning can keep communities connected, as opposed to focusing on the mode of connectivity itself.

Toward the end of the year, I myself was diagnosed with COVID-19. There were times during my recovery that I desperately wanted to be able to do something as simple as taking a walk, but physically, this was too taxing on my body. I realized the importance of repairing my own relationship with being outside. While today I still carry a heightened sense of caution when it comes to walking and jogging outside, I continue to do the work—on sidewalks and in planning processes—of asserting that cities can be made for me.

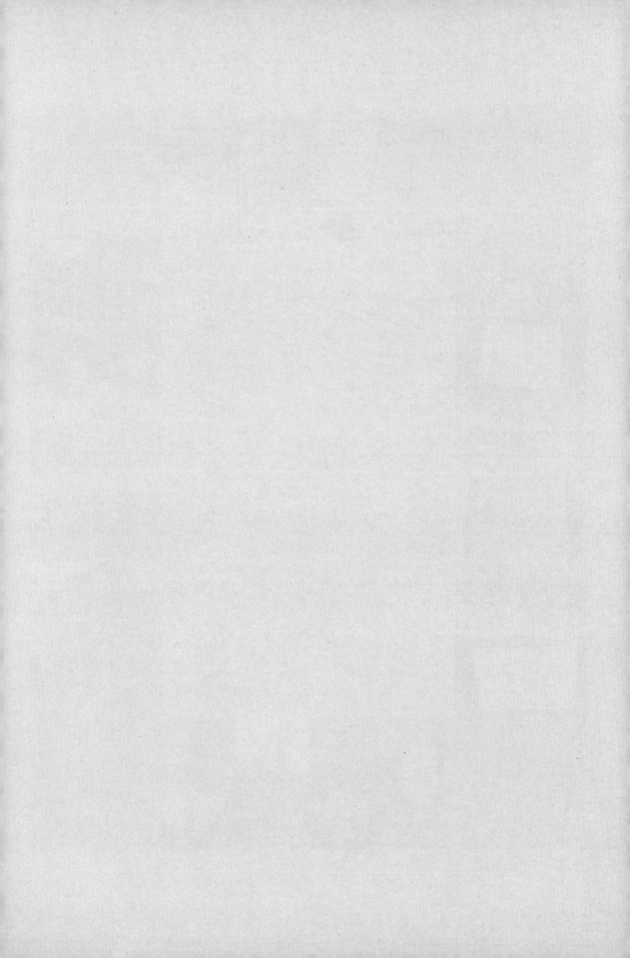

◀ **J. Kevin Byrne**, St. Paul, Minnesota, United States
I live in a high rise in downtown St. Paul, where I watched the Midway
district burn during the unrest that followed the murder of George
Floyd. As soon as it seemed feasible, I visited the site where he was
killed—38th Street and Chicago Avenue—and spent three hours
sketching and taking photographs. Upon my return to my studio
I created my map with GIS software and data from Minneapolis
Police Department reports that specify exact kinds of use of force.
Each black X is a typographically labeled arrest location, one of the
many covering years of police reports. Bloodred X marks the death
site of George P. Floyd, Jr. (1973—2020, RIP). I piped the map with the
photographs I took.

➤ **Christopher Damitio**, Honolulu, Hawaii, United States

While I was trapped at home, politics consumed me. This being an election year, it started to look like the country I loved and defended as a US Marine had become a number of different places. I rejoined Facebook in 2020. For some reason I thought that was a good idea. I reconnected with my college, Marine Corps, and Peace Corps friends. The country I used to know really became a different place. But the strangest thing was not being able to smile at or be smiled at by strangers. I hope that disappears in the future. I miss people's smiles. Maybe it's good we had the masks to hide our fear, our grief, and our anxiety, but I can't help thinking smiles would have made a difference.

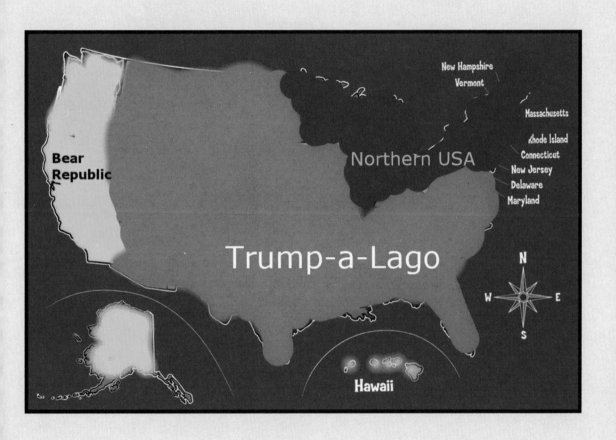

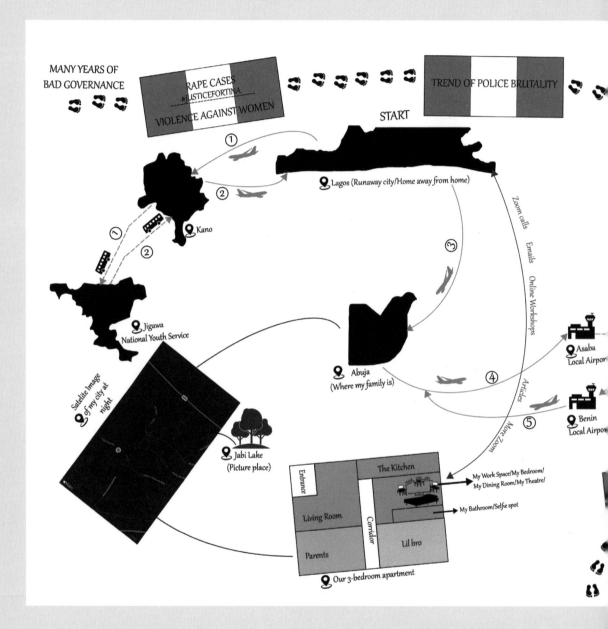

Social/Political path(events)

Flights

Road trips

Work activities

Location

Spent the most time

Spent the least time

Nigeria (My country)

#ENDSARSPROTEST
uths Peacefully Demanding
Their Right to Live

Grandpa
Agbor, Delta State

I MASSACRE
10-20-20
o gave the order?

RYING TO SURVIVE

◄ **Oghenetega Steffi Ogodo**, Abuja/Lagos, Nigeria
My map partially represents the social-political climate of my country during the pandemic and my personal journey of reconnecting with my city during the lockdown. It starts out with my home away from home—Lagos, Nigeria— and the trips I took between Kano and Jigawa (in the northern part of Nigeria) prior to the lockdown. I finally find myself in my home city (Abuja), trying to balance the new dynamics of my reality. The numbers represent the movements between cities during this period.

The main forces of transformation in my life were linked to the transition to working online and the emotional challenges that come with having a sibling with Down syndrome and managing my own life while assisting. I searched more for community and individuality at the same time. I had to find refuge in constantly restructuring my personal space to take away some of the anxiety that came with the new dynamics of living. At the end of it, I realized part of my individuality is connected to the control I have over spaces, like my bedroom.

Community came from exploring places in my city and reconnecting with old friends again. The park was a big part of my mental health and release. It was also a place I could see my brother explore for himself as an individual and independently through his photography. The year 2020 also made learning more about my family history so important. It took me on a journey to reconnect with my grandfather and discover more about his past life in Delta State, in the southern part of Nigeria.

With all this in my personal life, my map also tells the stories experienced by many others in my country during the pandemic, from the many years of bad governance to a clear demand for the end of police brutality (#ENDSARS, #SARSMUSTENDNOW, #ENDSWAT), and finally, the massacre of innocent citizens holding up the Nigerian flag on the twentieth of October 2020 in Lagos. The path for justice continues as we try to survive the coming days.

WORK

TEAM B'S EMPTY DESKS

EMPTY TRAINS

CROWDED BOATS TO SURROUNDING ISLANDS

NO MORE TRAFFIC

SHUTTERED STORES

HONG
KONG

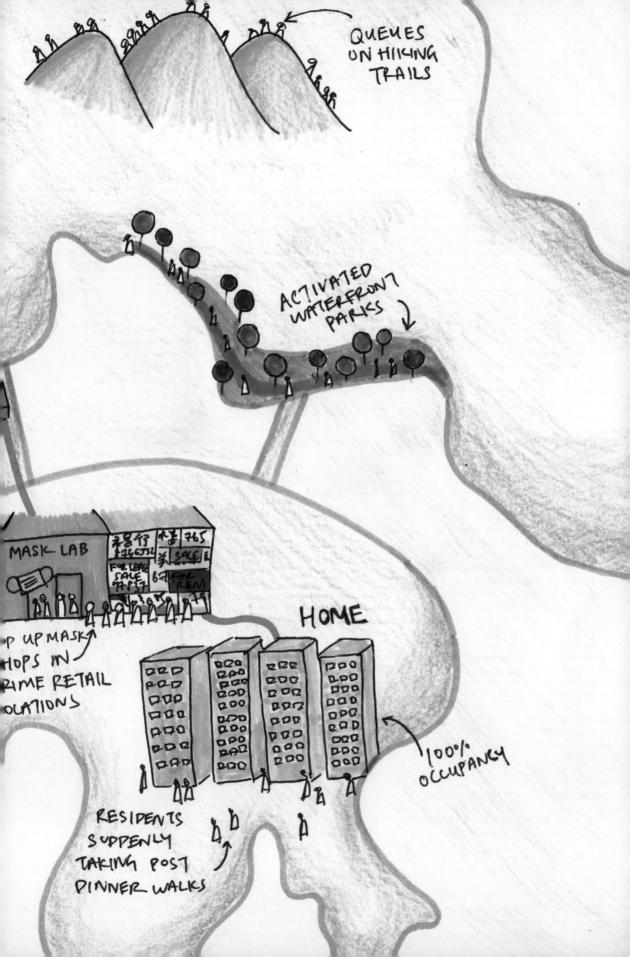

QUEUES ON HIKING TRAILS

ACTIVATED WATERFRONT PARKS

MASK LAB

程行
8366354

松菜 765
美 SALE

FOR LEASE
SALE

6

FOR RENT

P UP MASK
HOPS IN
RIME RETAIL
OCATIONS

HOME

100% OCCUPANCY

RESIDENTS SUDDENLY TAKING POST DINNER WALKS

◄◄ Tiara Lui, Hong Kong SAR, People's Republic of China
Taking reference from my commute, I mapped the changes to Hong Kong since the start of COVID. The morning rush turned into a quiet ride, routines staggered with the work-from-home schedules. The queues for bubble tea were replaced with the queues for fashionable marble-patterned surgical masks at a pop-up shop, which not long ago was a luxury goods store. Pro-democracy protests, the national security law, COVID-19: The map could be interpreted as simply the effects of COVID-19, but really it's the culmination of these forces. Shuttered stores and empty places: Has the Pearl of the Orient lost its luster?

➤ Justin Raymond Hernandez, Miami, Florida, United States
Quarantine has made me greatly miss seeing my friends and family. This got me thinking about how even under normal circumstances I still remain physically distant from them because I don't have my own car. I created this fantasy transit map to highlight a hopeful future in which I'd be able to see them with ease and without having to drive.

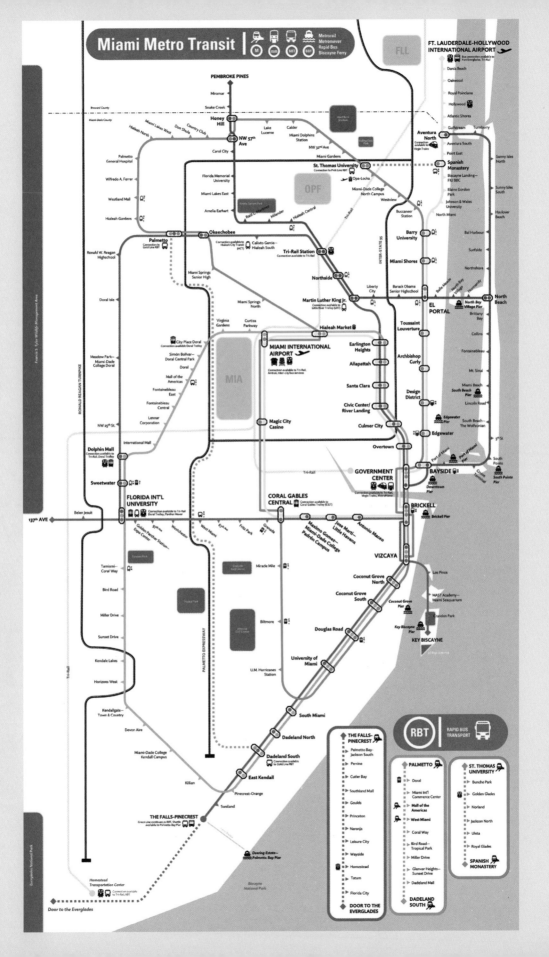

EXISTING OFFICE BUILDINGS
CONVERTED INTO WAREHOUSE,
DATACENTRE, NEW HOUSING AND
SKYFARMING

VERTICAL FARM

WILDFLOWER
MEADOW

ROOFTOP
NURSERY

COMMUNITY
ORCHARD

VEGETABLE
PLOTS

UNDERGROUND
TRANSPORTATION
SYSTEM

DISUSED UNDERGROUND
CONVERTED INTO GREEN
SPACES

WIND FARMING

GARDEN ROOF

URBAN FOREST

◄ **Walee Phiriyaphongsak,**
London, United Kingdom
In my vision for the post-pandemic future of cities, office spaces are converted into warehouses, data centers, housing, and vertical farms. Parking spaces will be transformed into orchards and gardens used by the community and, most important, the main streets will become endless wildflower meadows and woods. We will harvest the energy we need from the sun and wind, and everything will be recycled. As most of the office space will be converted into something else, there will be a radical shift in urban configuration: People will move out from the city center while skyfarming and urban warehouses will move in. Through rewilding our cities, we can re-establish our rightful place and be in harmony with nature.

Afterword

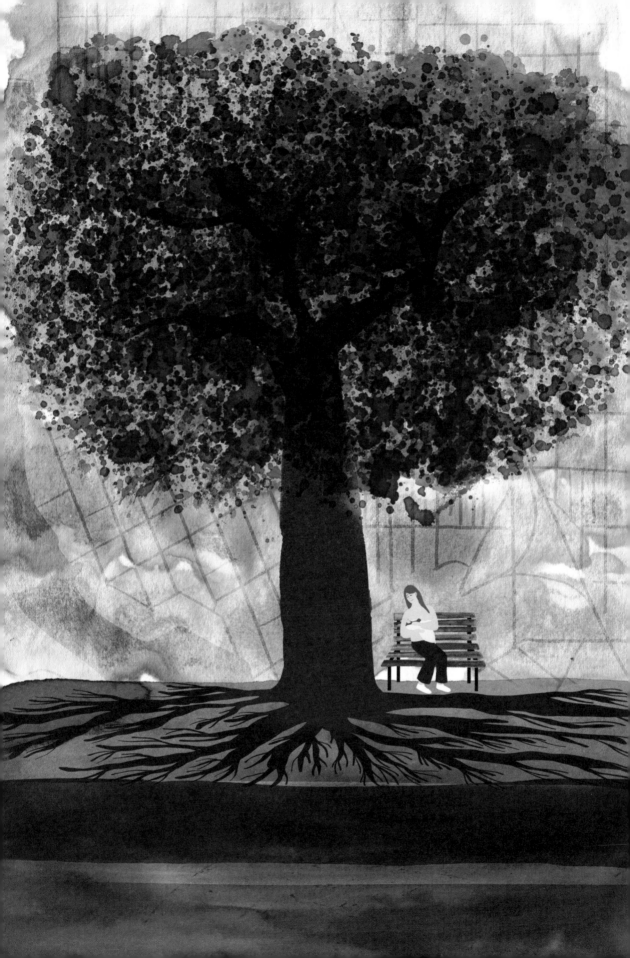

A Tiny Newborn World

Jessica Lee Martin

The first wave of panic hit as I sat in the corner table at my local coffee shop on a Sunday afternoon in early March 2020. The scene around me—people talking, the fan spinning above my head, a barista steaming milk—seemed to slow and quiet. Hanging in the airspace was a new and invisible medium threatening my very breath. I put my hand to my belly. Four months pregnant, I was expanding while the world was closing down, facing a third trimester now blanketed in fears and unknowns.

After that, my 0.37-acre property in the suburbs of Minneapolis, shared with my husband and three-year-old daughter, would be the place I spent my days. With our family out of state, the three of us attempted to scrape into existence a new daily cadence, balancing two full-time jobs with a rowdy toddler kept home from day care. As the virus raged and stripped back layers of normality, routines that once led me out the front door to work, day-care drop-offs, errands, and dinner dates were warped into endless circles around the house.

Pregnancy became a lonely journey. My new status as a member of the "vulnerable population" limited my outings to the barest necessities, where I'd savor brief moments interacting with strangers. I now navigated my prenatal checkups alone, glancing at my reflection in the wall of windows as I entered the building, noting my cloth

◄ **Jennifer Maravillas,** Brooklyn, New York, United States

mask and growing belly. I'd sometimes share a meaningful glance with another pregnant patient in the lobby—an attempt at solidarity, care, and connection. My doctor became the only other woman to touch my belly, as she measured the spark of life locked down inside of me. As other people kept a protective distance from me, my desire grew for a closeness that I couldn't have. My husband arranged a socially distanced baby shower outdoors in the backyard with local friends, neighbors, and colleagues. Under a towering elm tree, a circle of love spaced out in six-foot intervals surrounded me. I received no hugs.

It was in this landscape of isolation that CityLab's quarantine mapping project was born in April 2020. At the time, with pandemic changes still raw, scientific questions unanswered, and a rising global death toll, our call to readers to share maps of transformed places and spaces was a daring challenge. But the maps that hit our inbox were surveys of survival, lifelines manifested through art. Through ink on paper to swaths of penciled color to digitally created scenes, these artworks documented rebooted rhythms, hyper-local explorations, newly awakened eyes to the natural and built environments, and finding ground after being knocked off balance.

As an editor on the project, I was incredibly moved by the stories of courage in the maps and notes that we received with the submissions. Many people sent unsolicited words of appreciation and gratitude: For them, the invitation to create a map molded from such a difficult experience was cathartic, and a chance to see more clearly—if only for a moment—the beings and things that still oriented their lives.

Anxieties sharpened as my due date drew nearer. When family members refused to quarantine ahead of a planned visit, we frantically wondered who would watch our three-year-old daughter, Cora May, while we were at the hospital, if my husband was even allowed to accompany me. Women in advanced pregnancy were at more risk of COVID infection, scientists warned, and the news seemed to confirm this. I felt admiration reading articles about women giving birth at home to avoid hospitals, and terrified by tales of others who faced C-sections, induced labor, and ventilator hookups because they were COVID-positive. A photo of a new father in Minneapolis kissing his newborn baby girl, after the virus claimed his wife, burned itself into

my thoughts, as did the story of a five-year-old in Texas who lost both parents. I did not want to die and leave my girls motherless.

At thirty-eight weeks, I completed a final grocery store trip during a six a.m. time slot designated for people with higher COVID risk. I said a silent goodbye to the three older women at the check-out register, who every week would help me out with my cart and ask me about my baby. In my mind, they had stepped into my maternal family line, handling my food like a mama, caring for me like a grandmother.

One early evening after a particularly circus-like day of scrambling to get work done, stumbling through sciatica pain, and entertaining my toddler, I collapsed into a new nursing chair that I had arranged to face the elm tree outside my southern-facing bedroom window. Leaning back, I followed the tree's outline with my eyes from the ground up. I could picture its roots connecting earth to sky, and I imagined them holding me safely somewhere in between. I didn't know it yet, but that tree would be the view that would welcome my child. It would become my compass through the turbulent times ahead—including childbirth itself.

When a fierce summer monsoon sent me into labor, as the nurses would later explain, I envisioned the branches bending to weather the storm, as the force of life within my belly recontoured my own body. I pictured the first beam of morning light striking the treetop as I faced a clutch of female doctors behind face shields, as I labored behind a mask. When my little Josie Louise arrived, it was midday in late July. The caring doctor who caught her later returned to my hospital room to give me an "illegal hug."

I kept leaning on the tree for comfort and chronology. As I rocked the baby through sleepless nights, the stars drifting through its branches confirmed to me that the world hadn't stopped spinning. The glow of light across her bark marked the space between sunrise and sunset. The shuffle of crisp leaves was a sign of autumn. And in the winter, I strung a strand of colorful Christmas lights around her. As I write, we're entering our second pandemic spring, and her tiny buds whisper: The time to burst forth is nearly here.

Sometimes I wonder what my daughters will ask about this pandemic era. Will they want to know how millions of parents held down jobs with no schools or childcare for more than a year? Will Josie

Louise want to hear what it was like to meet our friends and neighbors from behind glass windows, about not being snuggled by her grandmothers before she began to crawl? Will they care to know the other steps we took to protect our family, like avoiding other kids at the playground and keeping them out of indoor public spaces for more than a year? Will they ask about the privileges our family had—jobs that we could do from home, delivered groceries, healthcare—and the others in our community who endured losses much greater and more permanent than our temporary breakdown of a social network? These words flow as much of the US remains immersed in this lockdown, more than a year after the pandemic was officially declared. I don't yet know all the answers about how we survived, or how we will emerge from this shifted landscape. What memories will fall away; which traumas will endure?

But I do know that these maps told part of the story of how we navigated an intensely intimate COVID journey, one that twisted and turned between loss and loneliness, sanity and sanctuary, courage and connection, fantasy and fear, endurance and elation, nature and nurture. These maps are evidence that we did make journeys in this pandemic, despite feeling stuck, disoriented, and alone. This cartographic collection tells the story that, despite the differences and distances that were so profound in this time, our experiences born in this era will forever connect us. We all have our own maps printed inside our hearts and minds. Mine is shaped like an old elm, with forked branches stretching wide like a net to catch sunlight and hope.

May we soon be able to find the routes that lead us back together again. Under the firmaments and boughs of the places and spaces we love, we'll tip our heads back in joy and breathe in the swishing sky.

Contributor Biographies

David Dudley is the executive editor of Bloomberg CityLab. A native of Buffalo, New York, he's the former editor-in-chief of *Urbanite* magazine and the co-creator of the rock opera *1814! The War of 1812 Rock Opera*. His writing has appeared in the *New York Times*, the *Atlantic*, *AARP The Magazine*, and other outlets. He lives in Baltimore, Maryland, with his wife and two daughters.

Sarah Holder is a writer and reporter based in San Francisco, where she covers economic and criminal justice, labor, and urban policy miscellany for Bloomberg CityLab. Her writing has been featured in *The Atlantic*, *Businessweek*, *Politico* Magazine, the *Yale Herald*, and a 2021 quaran-zine. She's originally from small-town New York, and came to the Bay Area by way of Washington, D.C.

Geoff Manaugh is a Los Angeles–based freelance writer and the author of the *New York Times*–bestselling book *A Burglar's Guide to the City* (2016). He regularly covers topics related to technology and design for the *New York Times Magazine*, *Wired*, the *Atlantic*, and many other publications. His book *Until Proven Safe: The History and Future of Quarantine*, co-written with Nicola Twilley, was published by MCD Books in 2021.

Jessica Lee Martin is the audience development editor at Bloomberg CityLab. In her journalism career spanning two decades, she has worked in the interface between the newsroom and its readers, leading social media and engagement strategies for *Guardian* US, *Democracy Now!*, and PBS Wisconsin. A lifelong fascination with maps has led her along hiking trails in Arizona, on European train routes, and exploring rivers from the Yangtze to the Nile. She has yet to find buried treasure. She has a degree in environmental science and lives in Minneapolis with her husband and two daughters.

Angely Mercado is a New York City–based writer, researcher, and fact-checker who is still learning how to take weekends off. Her work focuses on environmental justice, climate justice, tech, and New York City policy. She's been featured in the *New York Times*, the *Nation*, *Grist*, the *Guardian*, and more.

Taien Ng-Chan is a writer and award-winning media artist whose interest in alternative practices of mapping informs her work as a founding member of the Hamilton Perambulatory Unit, and as chair of the Commission for Art and Cartography at the International Cartographic Association. In addition to essays in such journals as *Humanities* and *Intermediality*, Taien has published four books and anthologies of creative writing, produced multimedia arts websites, and written for stage, screen, and radio. Her media works have been exhibited internationally in film festivals, galleries, and conferences. She is a professor in cinema and media arts at York University in Toronto.

Jenny Odell is an interdisciplinary artist and writer based in Oakland, California. Her work often promotes bioregional awareness and close attention to the everyday. Odell is the author of *How to Do Nothing: Resisting the Attention Economy* and has been an artist in residence at Recology SF (the dump), the Internet Archive, and the San Francisco Planning Department.

Linda Poon is a reporter for Bloomberg CityLab, based in Washington, DC. She writes about the intersection between cities and the environment from climate change's effects on communities and public health to green urban design. She also enjoys exploring the cultural quirks of urban living. When she's not writing, she likes to explore new cities, looking for hidden gems—or escape into the woods.

Dr. Destiny Thomas is a change agent and an anthropologist planner. She is the founder and CEO of Thrivance Group and was featured on *Good Morning America* for her leadership in the urban planning sector. At Thrivance Group, Dr. Thomas works to bring transformative justice into public policy, urban planning, and community development. With more than fifteen years of experience shaping key policy initiatives, Dr. Thomas believes race, place, and joy define individual and community outcomes.

Art Credits

page xiv © Laura Bliss; **page 2** © Taien Ng-Chan (for the Art and Cartography Commission); **pages 8–9** © Patty Heyda; **pages 10, 11** © Peter S. Conrad; **pages 12–13** © "Mapping the Quarantine life in Raja Park," Pooja; **pages 14–15** © Edda Ivarsdóttir; **pages 16–17** © Nabilla Nur Anisah; **pages 18–19** © Blanca Juan; **pages 20–21** © Daniela Pardo; **pages 22–23** © James Hennessey; **page 25** © Sharmaine Andrea Montealegre, 2020; **pages 26–27** © Sine Taymaz; **pages 28–29** © Samantha Emrich; **page 31** © Stentor Danielson; **page 32–33** © Diem-Han (Ti) Dinh; **pages 34–35** © Gro Njølstad Slotsvik; **page 36–37** © Francisca Benitez B.; **pages 40, 46** © Jennifer Maravillas; **pages 51, 52–53** © Aditi Shah; **pages 54–55** © Amit Krishn Gulati, 2020; **pages 56–57** © Amna Azeem; **pages 58–59** © Arthur Beaubois-Jude; **pages 60–69** © Axel Forrester / www.axelforrester.com; **page 70** © Rawnak N. Zaman; **pages 72–73** © Simo Capecchi—taccuinidellaquarantena.tumblr.com; **page 75** © Lisa Rose Drury; **pages 76–77** © Eric Hoke; **pages 78–79** © Nawaf Al Mushayt; **pages 80, 81** © Lydia Wei; **pages 82–83** © Alfonso Pezzi; **page 84** © Champ Turner; **pages 86–87** © Constance Brown; **pages 88–89** © Diana Dobrin; **pages 96–97** © Brian Palmer; **pages 98–99** © Maria Claudia Canedo Velasco; **pages 100–101** © C.X. Hua; **pages 102–103** © Richard Bohannon; **pages 104–105** © Darrell Hawkins; **page 106** © John Palumbi; **pages 108–109** © Justin Lini; **pages 110–111** © Kate Rutter; **page 113** © "Miracle Max Island," Lori Melliere, 2020; **pages 114–115** © Stephanie Bhim; **page 124** © Peter Gorman; **pages 126–127** © Candelaria Mas Pohmajevic, 2020; **pages 128–129** © Emily Erdos; **pages 132, 138** © Jennifer Maravillas; **pages 143, 144–145** © Anna Roberts-Gevalt; **page 146** © Louis McNair; **pages 148–149** © Noah Tang; **pages 150–151** © Jane Black; **page 152** © Mary Sharber; **pages 154–155** © David Scales; **page 157** © Jessica Wade; **pages 158–159** © Jacob Harrell; **page 161** © Susan Sullivan; **pages 162–163** © Marta Petteni; **pages 164–165** © Ezra Silkes; **pages 166, 167** © Ele Denne (Instagram: @got_to_gogh); **pages 168–169** © James Crossley; **pages 170–171** © Jean Farley Brown; **page 174** © Jennifer Maravillas; **page 180** © J. Kevin Byrne, "Forceful Typography 2020," licensed CC BY-NC-ND 4.0; **pages 183** © Hawaii Tiki Group LLC; **pages 184–185** © Oghenetega Steffi Ogodo; **pages 186–187** © Tiara Lui; **page 189** © Justin Raymond Hernandez; **pages 190–191** © Walee Phiriyaphongsak; **page 194** © Jennifer Maravillas.

Laura Bliss is a writer, reporter, and editor. On staff at Bloomberg CityLab, she covers cities and the environment and writes the newsletter MapLab, which explores how maps illuminate the world around us. Her work has appeared in the *New York Times*, *The Atlantic*, *Bloomberg Businessweek*, *Los Angeles Review of Books*, WILDSAM's guide to California, and other publications. She hails from Los Angeles, where she once worked as an educator at the Natural History Museum and La Brea Tar Pits, and now lives in San Francisco.

Bloomberg CityLab is committed to telling the story of the world's cities, communities, and neighborhoods: how they function, the challenges they face, and potential solutions. Founded by urban theorist Richard Florida in 2011 under the aegis of the Atlantic Media Company, CityLab was acquired by Bloomberg Media in January 2020. With global issues such as climate change, income inequality, and new technologies affecting urban areas, CityLab is focused on ways to prosper together. CityLab is inspired by the concept that cities are laboratories for democracy and embraces that spirit of experimentation in its journalism.

laurablisswrites.com
bloomberg.com/citylab

🐦 @mslaurabliss; @citylab
📷 @citylab
📘 @thisiscitylab